WAITING FOR THE END OF THE WORLD

D1268691

.

.

.

WAITING FOR THE END OF THE WORLD

.

Richard Ross

.

.

.

With an Interview
by Sarah Vowell

.

.

.

Princeton Architectural Press
New York 2004

.

.

.

.

.

.

.

Published by
Princeton Architectural Press
37 East Seventh Street
New York, New York 10003

•

For a free catalog of books, call 1.800.722.6657
Visit our Web site at www.papress.com
Visit the author's Web site at www.richardross.net

•

•

Every reasonable attempt has been made to identify owners of copyright. Errors or omissions
will be corrected in subsequent editions.

•

Editor: Nicola Bednarek
Designer: Jan Haux

•

Special thanks to: Nettie Aljian, Janet Behning, Megan Carey, Penny (Yuen Pik) Chu, Russell
Fernandez, Clare Jacobson, Mark Lamster, Nancy Eklund Later, Linda Lee, Katharine Myers,
Jane Sheinman, Scott Tennent, Jennifer Thompson, Joseph Weston, and Deb Wood of Princeton
Architectural Press—Kevin C. Lippert, publisher

•

Cover: This three-family shelter in San Pete County, Utah, located more than twenty feet
underground, is fifty feet in length and ten feet in diameter. It includes a separate twenty-
eight-foot bathroom and shower area. (Photographed 2002)

•

Library of Congress Cataloging-in-Publication Data
Ross, Richard, 1947-
 Waiting for the end of the world / Richard Ross ; with an interview by Sarah Vowell.
 p. cm.
 ISBN 1-56898-466-9 (alk. paper)
 1. Architectural photography. 2. Photography of interiors. 3. Fallout shelters—Pictorial
works. 4. Nuclear bomb shelters—Pictorial works. I. Title.
 TR659.R6294 2004
 779'.4'092—dc22
 2003026233

CONTENTS

.

.

.

.

.

.

.

.

.

.

.

.

.

.

ACKNOWLEDGMENTS

•

This project was made possible by the help of many generous people. Those who allowed me access to the shelters made a great leap of trust by permitting me to visit and photograph them, and to publish these images. Others assisted in providing contacts, publications, and ideas. Notable are Paul Seyfried and Sharon Packer of Utah Shelters; Steven May of Abbott Data Systems; Jurg Jent and Hans Riedo of Andair AG Systems; Bus, Dragon, and Veterok of the "Gugno Diggers" Underground Team; Lynn Swann of the Greenbrier Hotel and Resort; Mark Davis of the Los Angeles Office of Emergency Planning; Mark Washburn of the *Charlotte Observer*; Paul Sakristan of KFWB Los Angeles; Gary Geoff of Montgomery Developers; Mark Duggan of FEMA; Maisie Todd and Brad Lemeley of *Discover Magazine*; Laura Lindgren and Ken Swezey of Blast Books; Erin, Nancy, and Rod Chiamulon; Alice and David Quinn; John and Carol Boom; Nick Gruzdev; Kelly Welch; Mike Parrish; J. D. Talasek; Zhu Bing; Al Maxwell; Philip Hoag; and Charlie Hull.

The book is made coherent by the efforts of my editor, Nicola Bednarek, and elegantly designed by Jan Haux.

People that helped me by carrying cameras and traveling not only to the ends of the earth but under it are Joan Tanner; J. B. Jones; Alan Moore; Ben Northover; and, of course, my most dedicated assistants, Leela, Nick, and Cissy Ross.

Assistants in Santa Barbara who endlessly printed and labeled images for the book and created the Web site are Jessica Paulsrud, Erin Bigley, Sanem Salek, Meg Messina, Rebecca Greenberg, Rob Nite, and Teja Ream.

A special note of thanks to Julien Robsen, Stephen Foster, Meg Linton, and Karen Sinsheimer, who have always supported my efforts in both word and deed.

•

Richard Ross, Santa Barbara, 2003

•

•

•

•

FOR MY FRIEND JOE POLLOCK,
THE ETERNAL OPTIMIST

-
-
-
-
-
-
-
-
-
-
-
-
-
-
-
-
-
-
-

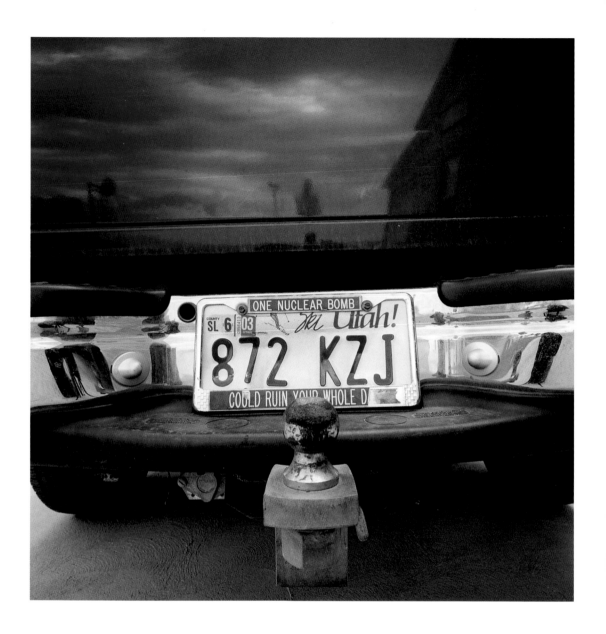

AN INTERVIEW WITH RICHARD ROSS
BY SARAH VOWELL

-
-
-
-
-
-
-
-
-
-
-
-
-
-
-
-
-
-
-
-
-
-
-

Sarah Vowell: I envy you. You've been to Greenbriar! My favorite vacation is to go someplace where something really horrible happened, like the Salem witch trials or Wounded Knee, but to stay in a really nice hotel. So Greenbriar is of course my holy grail—a swank resort with its very own bomb shelter museum. What can you tell me about that discrepancy between horseback riding and spa treatments, and a formerly secret Congressional fallout complex?

•

Richard Ross: Greenbriar is a WASP heaven in rural West Virginia. For thirty years the existence of a bomb shelter for the US Congress underneath the elite resort was kept secret. The structure, which has thirty-ton blast doors and could hold 1,800 people, was built during the Eisenhower administration. Interestingly, it was stocked with alcohol but no condoms.

The Laura Ashley-on-acid décor above is in stark contrast to the austerity below. In this surreal world, Congress would function in what looks like a high school auditorium with a photomural of the Capitol in the briefing room. This, theoretically, would allow a speaker of the House or Senate leader to appear on TV in front of the "Capitol" and offer assurance to the nation as if everything was normal.

The shelter was "outed" in 1992 and since then has become primarily a tourist attraction.

•

SV: Those places where evil and beauty coexist so blatantly feel very American to me. Like your photograph of those air vents in Montana. At first, the picture seems like just another purple mountains majesty postcard vista, until one realizes what those air vents are for, what those air vents are about.

•

RR: I feel guilty about the existing beauty in some of the images. After years of photographing and working with light, I can take a pile of rubbish, light it intensely, and make it look like magic. These places are chilling physically with a preponderant, eerie stillness. I think they have a distinctly diabolical beauty.

The Emigrant Mountains in my picture stand in stark contrast to what lies beneath. The air vents were shot specifically with the breathtaking landscape in the background to emphasize this. A casual passer-by would never see these vents and could not suspect what they signal below. In effect, we are all casual viewers of the landscape. For reasons unknown I have taken on the odd responsibility of making what is hidden, visible—by changing the status of these structures from covert to overt.

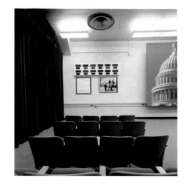 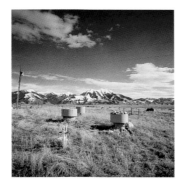

SV : Who are Phillip Hoag and Charlie Hull?

RR : Phillip Hoag authored the book *No Such Thing as Doomsday* and hosts the Web site www. nodoom.com. He is a nice guy who helps broker power plants in underdeveloped portions of the world. He is peripherally involved with the Elizabeth Clare Prophet group and the Church Universal Triumphant. Charlie Hull is a retired teacher from Fresno, California, who is also a member of that church. He built a bomb shelter to house about ninety families, which he estimated cost over a million bucks. Hull was wistful in describing the number of vacations in Hawaii, new boats, or cars that have gone into the shelter.

Hoag let me spend the night in his shelter, a space cavernous enough to house several hundred people. It is a little bit like a *Popular Science* project gone array. Originally, both his and Hull's shelter were built as the result of a real threat—the proximity to the Intercontinental Ballistic Missile fields of eastern Montana—mixed with the doomsday prophesy of the Elizabeth Clair Prophet sect.

SV : Funny you mention that, because I grew up in Montana, and I was simply obsessed with nuclear war. When I was sixteen, I could have drawn you a map of those missile sites, or, as I would have thought of them back then, targets. In some ways, I was relieved to live in a place that was so clearly on the Soviets' radar, because I was more afraid of living than dying. I was petrified of nuclear winter specifically. Because I'm from the last real cold war generation: post-shelter. The shelters seem very Eisenhower-era to me. They're relatively happy and hopeful because they assumed a person could survive and would want to. But by the time I was old enough to start planning a future, I was pretty sure I wouldn't have one. I'm still amazed I got to grow up. Amazed!

RR : Through my reading—which I admit has been compulsive—I realized that nuclear winter might be a myth, the equivalent of a global urban legend. The optimal effectiveness from a nuclear blast occurs at significant altitudes, not ground zero. Ground bursts, which generate more fallout, release more atmospheric contaminants (dust clouds + blocked sun = nuclear winter), but ground bursts are less effective in the magnitude of total destructive power and therefore less likely to be used in a nuclear strike.

There are innumerable things to fear about a nuclear exchange that are symbolized by the existence of shelters designed to protect a citizenry from an overwhelming, devastating attack. If you put the

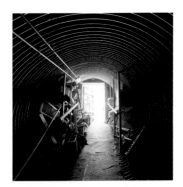
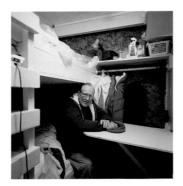

images of people's fears into a visual representation, the clear winner is the mushroom cloud—the poster child of the cold war. I think the bomb shelter, specifically the blast shelter, has been something that has existed as a literary or intellectual idea but never as a visual image. My goal with this project was to reexamine these locations—to visualize them and evoke their present status. And thereby make them real and tangible.

Working on this project I realized that there is such a minute number of extant shelters that they are ineffective as a logical solution or salvation. The destruction that can be caused by a nuclear (chemical/biological) exchange is so vast that the number of people who could be "saved" by a shelter system is inconsequential, and, in fact, is illusory. Regardless of the number of shelters, a nuclear exchange means an end to civilization as we know it. It may not end all life, but it would certainly be the most drastic evolutionary hiccup experienced by humankind and way beyond the scope of the horrendous legacy of Hiroshima.

I think the fears you have about nuclear winter mainly involve worrying what the corpses will look like. I don't want to denigrate your concerns, but I see them as fears concentrating on the details rather than focusing on the death of civilization. Maybe that's how we, as individuals, deal with death. The big picture, the demise of the world, is relegated to unimportant, being inconceivable, unbelievable. It's the "little" things like our own mortality that obfuscate the enormity of world endings.

•

SV : Oh, you're just saying that to cheer me up! In high school, my friends and I started an anti-nuclear group. Looking back, it seems so adorable, that we were teenagers in the middle of nowhere who thought handing out pie charts of the federal government's defense spending budget in grocery store parking lots would do any good. We didn't have a lot of members, though. I remember once we arranged to show a film about the effects of nuclear winter—I told you I was obsessed—during lunch, and the only person who showed up to see it was a West German foreign-exchange student. Do you ever have that problem? Getting people excited about looking at fallout shelters, I mean? What has been your experience in terms of getting people to come look at pictures of things most people would rather forget?

•

RR : Looking at things you would rather not confront? You have just described the human condition. Who wants to look or even think about architecture for the end of the world? I have always believed in

Ernest Becker's argument that the denial of death is predominant in defining the human condition rather than the Freudian sex drive. Do people want to think about sex or death? The answer is pretty evident from human behavior.

·

S V : I have a friend who says that when he was in high school and his sex-ed teacher said that boys his age think of sex several times a minute, he remembers sitting there thinking, "No, death. I think about death every twelve seconds."

·

R R : Many of the shelters are almost womblike, structurally organic spaces with an entrance resembling a reversed birth canal: a mysterious, inviting, convoluted tunnel with a light at the end of it, promising security, protection, nutrition, and life-granting safety inside. Think of reemerging from this sanctuary and being reborn into a world that is fearful and drastically changed from what we had known before and from what we imagined could happen. Sex and death all tied together—it is getting too metaphorical for me.

·

S V : When I was in college studying art history, I went through this modernist phase. I really bought into all those high modernist ideals about industrialism and the machine age. One thing the modernists taught us was to find the beauty in factories and grain silos and rivets and bolts. I'm reminded of that ethos in your images. They're beautiful—perfect compositions, almost religious light. Except, unlike, say, Charles Sheeler's photos, yours have this edge. Instead of being an example of human progress and efficiency, these shelters are examples of how our progress let us progress to the point of mutually assured destruction. Would you talk about that? About finding aesthetic beauty in these bad ideas?

·

R R : I am drawn to sites where benign neglect dominates. Many of the shelters I visited are abandoned or not used. The sparse light in these shelters is clean, symmetrical, undisturbed—waiting for my camera.

Does this "safe-keeping" architecture represent progress? It represents massive delusion. Efficiency? For whom? If an infinitesimally small portion of the species survives, is this efficient for the group as a whole? On some level, perhaps it is. I really don't know how to define the human condition anymore.

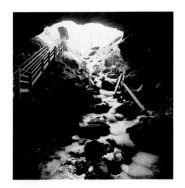
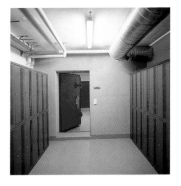

Looking at it from a theological standpoint, it is interesting to note that almost every civilization has ascension myths. Going up—arising, ascending into Heaven *above*—achieves salvation. Hell is the big descent—going down into hell. But this liturgical depiction confuses the issue of below-ground salvation. *Any* light looking up and out toward the environment in this context represents a blast, destruction, apocalypse. Light, which we usually gravitate toward, here brings massive death and obliteration.

The only civilization that I know of that doesn't practice any ascension dogma is the Native American people. They believe Mother Earth opens up and embraces an individual when life has been completed. Maybe the predominance of these shelters in western states is an admission that the natives of this country had it right.

.

S V : One of the photos is of a civil defense meeting at Salt Lake City's city hall. When was that and what were they saying?

.

R R : There are several images of people meeting in these shelters. In Salt Lake City there is a civil defense meeting once every month, during which people exchange information on ventilation, communication, and nutrition in case of emergency. In Switzerland I observed an orientation meeting of high school students learning the intricacies of the group shelters. Allegedly, in Switzerland 110 percent of the population can be housed underground in two hours. These people in Switzerland and Utah are serious. I think if there were a real nuclear exchange, the survivors would be Bush, Cheney, some Israelis, the Swiss, the Mormons, and assorted insects—a curious mixture.

.

S V : The picture in England of a highway marker for Kelvedon Hatch that says "Secret Nuclear Bunker" is hilarious. What is that place?

.

R R : Kelvedon Hatch is in Essex, England. It started out as a rotor station, then became a cold war defense bunker, and later served as a decentralized governmental post-apocalyptic station. The massive structure, which is today privately owned, spreads out over three levels. The owners cater private parties and offer tours through the shelter. As any other tourist attraction, Kelvedon Hatch depends on advertising and signage to attract visitors.

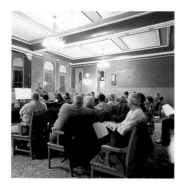 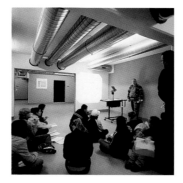 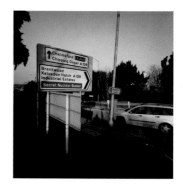

SV: I was amused by how much the two dummies in the bunk bed recalled that Ed Kienholz installation of the mental institution, though yours might be creepier if that's possible.

•

RR: What's creepier than institutionally anticipated destruction and acceptable casualties? Kienholz doesn't stand a chance.

•

SV: The Moscow pictures are fascinating. I caught myself enjoying their crumbliness. Like in my head I still haven't completely stopped fighting the cold war. I was alarmed at how nostalgic I felt. Not that I miss the USSR, but all my formative years were so part of that old world of the Berlin Wall and the KGB. I've had the same address book most of my life, and there are still old addresses in it marked "West Germany." But all that has vanished to the point that looking at your pictures makes me feel saner. That old familiar world is so far gone that sometimes I catch myself thinking I dreamed it.

•

RR: I felt I had to document the shelters in Moscow. The USSR was the other end of the nuclear "dumbbell." Most of their metro system doubles as shelters for the masses, and the stations are ornate masterpieces. Gaining access to shelters with governmental permission proved a nightmare. So Moscow became a breaking and entering event for me. Fortunately, I didn't end up as a *Law and Order* episode in Russia, although at times it was touch and go. I went around with nameless associates, and we entered shelters with bolt cutters and Allen wrenches. We opened hatches, waited until patrols went past in the darkness, hid in bushes, then lowered ourselves twenty feet with ropes under buildings such as the Moscow State University or apartment houses, climbed over transoms, and crawled through rubble. I worked mostly from 10 PM until dawn. My poor wife was forced to sit in a hotel and wait and worry.

One shelter had doors that were welded shut. We simply peeled back the corrugated steel roof and descended, only to discover that there was another entrance a few hundred feet away where people could walk in and out undiscovered. This apartment house shelter was originally built for the residents but was later converted into a listening post for the KGB. The out-of-sight entrance was used by the KGB to sneak into the underground rooms where they listened to tapped phones.

There is a pretty exciting museum in Siberia built in a bomb shelter that I think would be a great place to exhibit the photographs—again, a world of ironies.

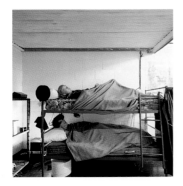
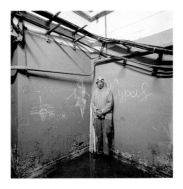

S V : What, ultimately, do these places mean to you?

R R : Shelters are the architecture of failure—the failure of moderation, politics, communication, diplomacy, and sustaining humanity. They represent the ultimate in optimism and belief in individual survival and paradoxically the ultimate in pessimism—the expectation of the destruction of humanity. The architects of these structures envisioned an inevitable cataclysm. It doesn't get worse than this. That said, everything about this project is counterintuitive. I am optimistic when I find shelters that are unused and abandoned. Conversely, I am depressed when I come across shelters that are gleaming and inviting, such as some of the Swiss shelters where classes in preparedness are taught.

In St. Petersburg, Russia, I photographed "The Trendy Griboyedov Club." I found it wildly optimistic. People use these clubs—converted underground shelters—to drink, dance, and mate. This is a celebration of life rather than an anticipation of death and destruction. The club rejects the intent and purpose of its origins. Finally it made sense.

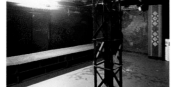

-
-
-
-
-
-
-
-
-
-
-
-
-
-
-
-
-
-
-
-
-
-
-

LOCATIONS

This small shelter in Salt Lake City, originally a fuel tank, was built as a supplement to a more capacious shelter the family owns farther away from their home. Reached through a tentlike entrance, the shelter serves mainly as a sanctuary for the family. Here, everything is impeccably in order, whereas the house itself is littered with toys, clothes, and books owned by the family's three children. The shelter's scale and facility are limited, as there will presumably be time to travel to the larger shelter in case of an emergency. The transition tunnel from the vertical entrance to the blast-proof room was painted yellow to make a friendlier passage for the two youngest children. "Any residence with a proximity to a runway over 7,000 feet long is a target," claims the builder and owner of the shelter. Salt Lake City airport qualifies under this criterion.

.

.

.

.

.

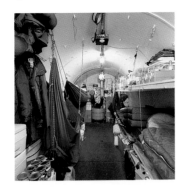

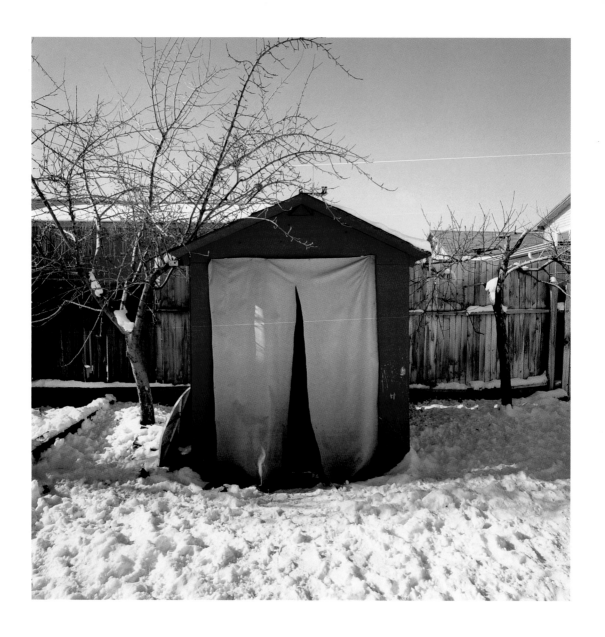

Salt Lake City, Utah, 2003

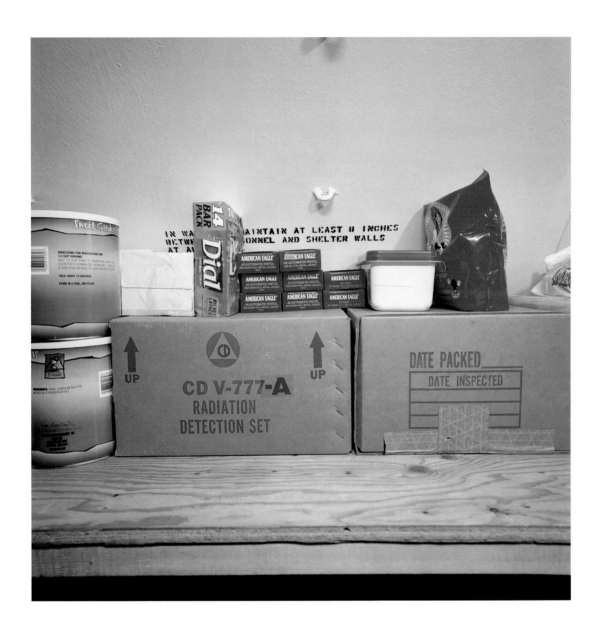

Salt Lake City, Utah, 2003

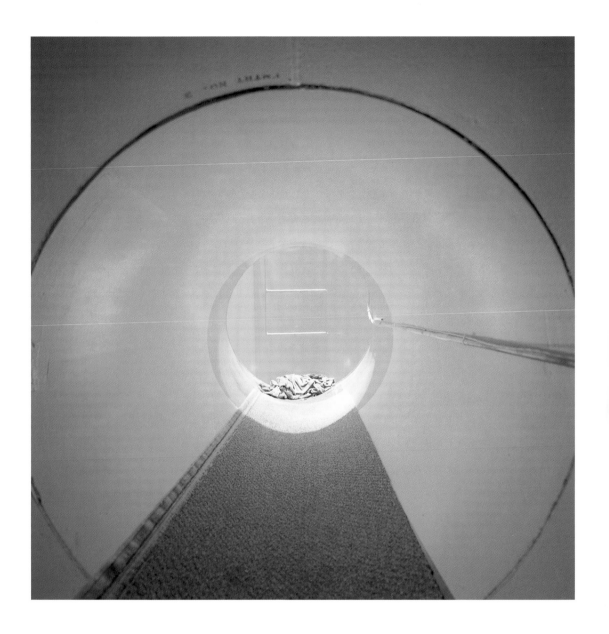

Salt Lake City, Utah, 2003

This group shelter was built by followers of Elizabeth Clare Prophet—members of the Church Universal Triumphant in western Montana. It was designed to house approximately ninety families, including one of the members of Men at Work, the Australian rock group from the 1980s. As with many of these community shelters built during the mid to late 1980s, interest in the shelter dissipated, leaving only a small group of supporters willing to pay the maintenance fees. The managing partner, Charlie Hull, is a retired schoolteacher from Fresno, California.

Each of the ninety families for which the shelter was built chose their own spaces and equipped them with what they deemed necessary for their transition from a pre- to post-apocalypse—some decorated their spaces with pink lace or hung up pictures. The shelter includes a number of common rooms as well as a larger bedroom with a private bathroom designated for the most committed participant. A sign-in chalkboard at the entrance is used by those who visit the shelter so that they will not be accidentally locked in.

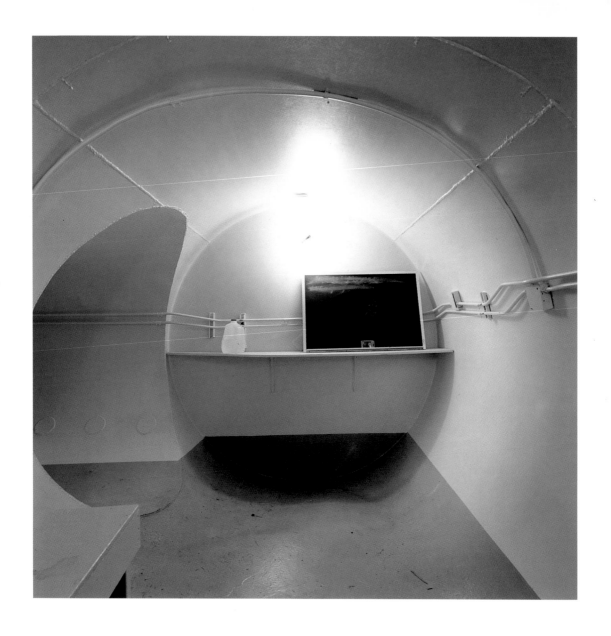

Charlie Hull's shelter, Emigrant, Montana, 2003

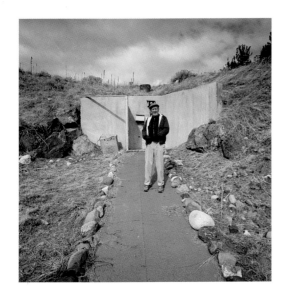

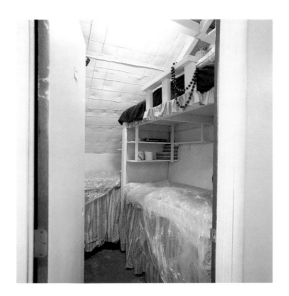

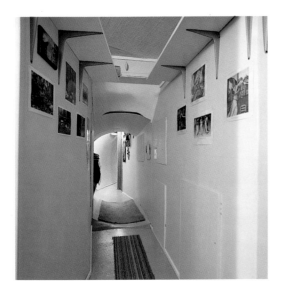

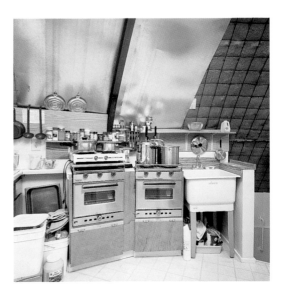

Charlie Hull's shelter, Emigrant, Montana, 2003

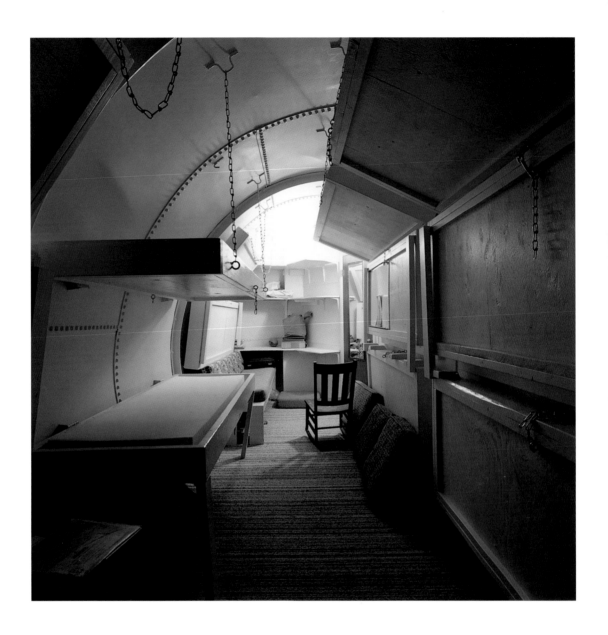

Charlie Hull's shelter, Emigrant, Montana, 2003

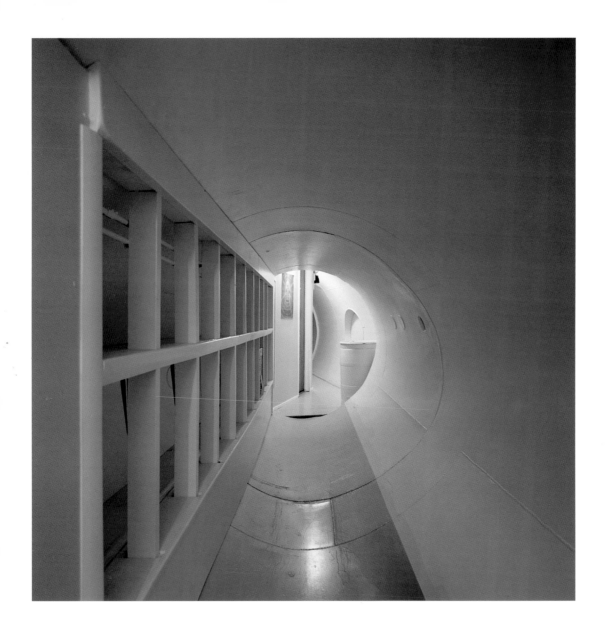

Charlie Hull's shelter, Emigrant, Montana, 2003

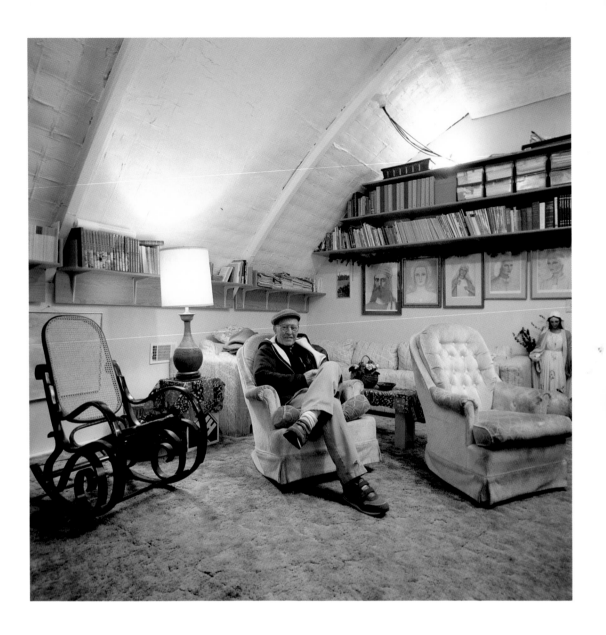

Charlie Hull's shelter, Emigrant, Montana, 2003

Dunn is a private school located about thirty miles from Vandenberg Air Force Base. In 1962 a fallout shelter that could house the entire population of the school was funded by a parent to ensure the safety of his son who wanted to attend Dunn. Forty years later, two students pose by an air vent. Currently, their main concern is pending applications for admission to the University of Southern California. They have never seen the inside of the shelter.

.

.

.

.

.

.

.

.

.

.

.

.

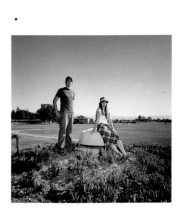

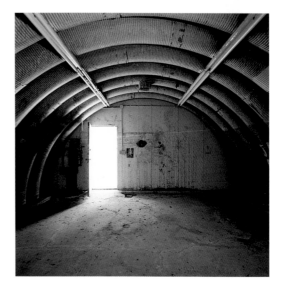
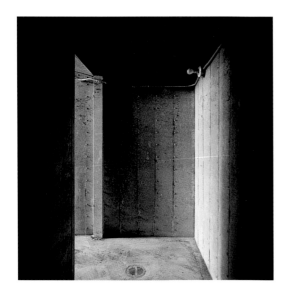
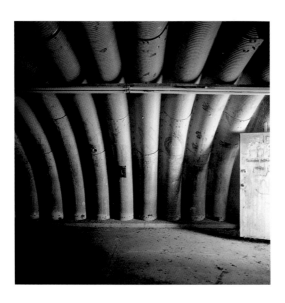
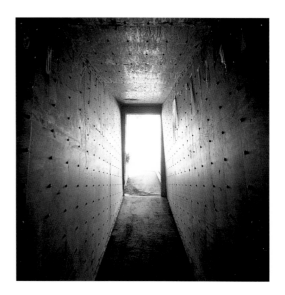

Dunn School, Santa Ynez Valley, California, 2003

When I visited this shelter, which was built during the cold war for an apartment complex near Kutuzovsky Prospect in Moscow, it looked as if someone had recently been living in these quarters. Air filters were in place, and a map of western Russia hung on one of the walls. Several incandescent lights were still functional.

Access to the shelter was through an air vent on a street opposite the apartments, followed by a long crawl through a fifty-foot-long transition tunnel under the street.

.

.

.

.

.

.

.

.

.

.

.

.

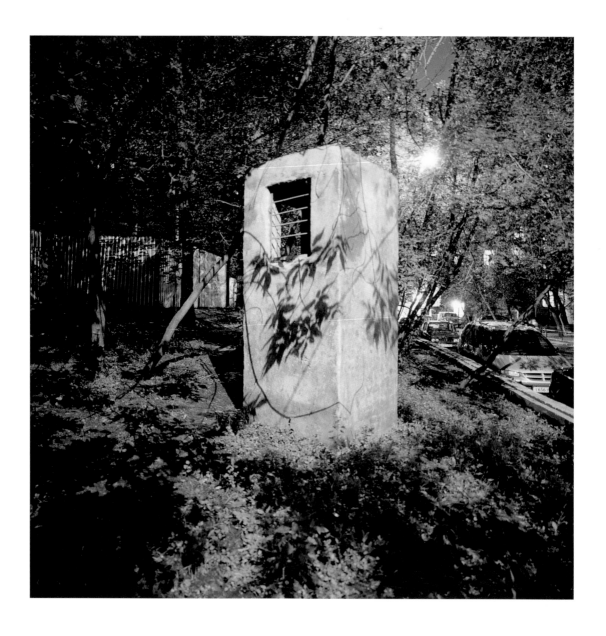

Kutuzovsky Prospect, Moscow, 2003

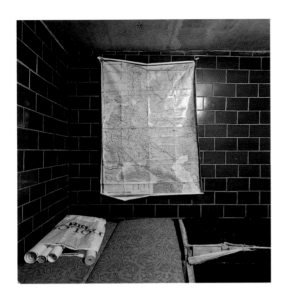

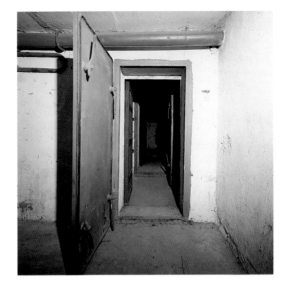

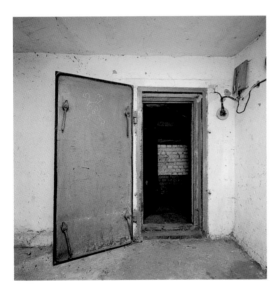

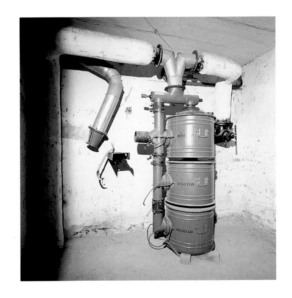

Kutuzovsky Prospect, Moscow, 2003

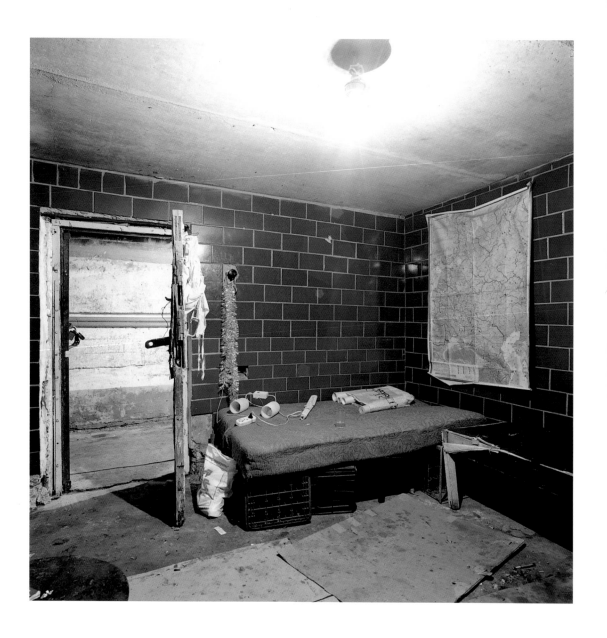

Kutuzovsky Prospect, Moscow, 2003

This multiroom complex, located under an apart-
ment house on Bolshaya Bronnaya Street in Moscow,
was built to hold approximately 750 people.
The entrance — now locked and barred to prevent
squatting — is in the basement of the main build-
ing. In the shelter I found large tanks labeled in
Cyrillic letters that said Drinking Water, and
ducts over sinks that were still functional.

 During the cold war, almost every apartment
complex in Moscow had a shelter that could be
accessed by the "block manager" who possessed the
key and would open the shelter upon orders from
the government.

.

.

.

.

.

.

.

.

.

. .

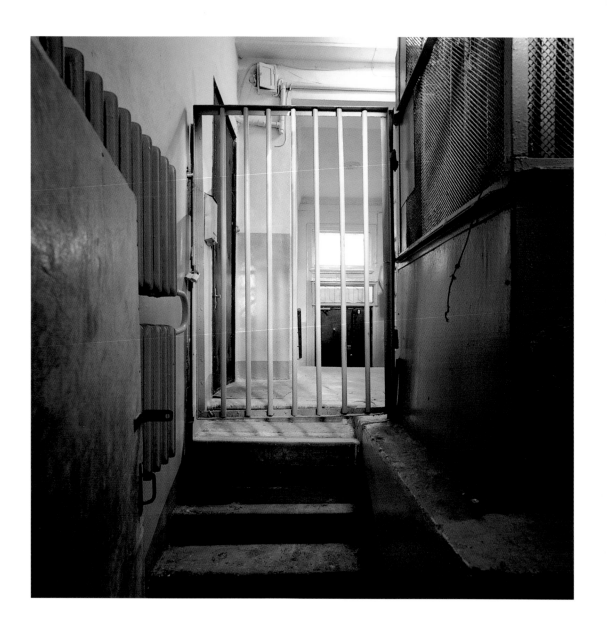

Bolshaya Bronnaya Street, Moscow, 2003

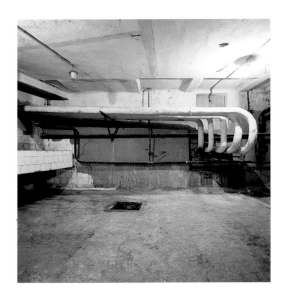
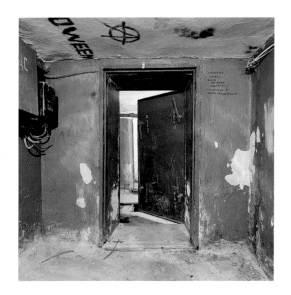
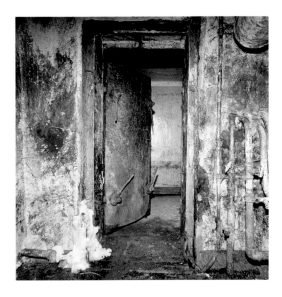
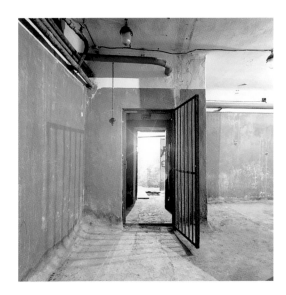

Bolshaya Bronnaya Street, Moscow, 2003

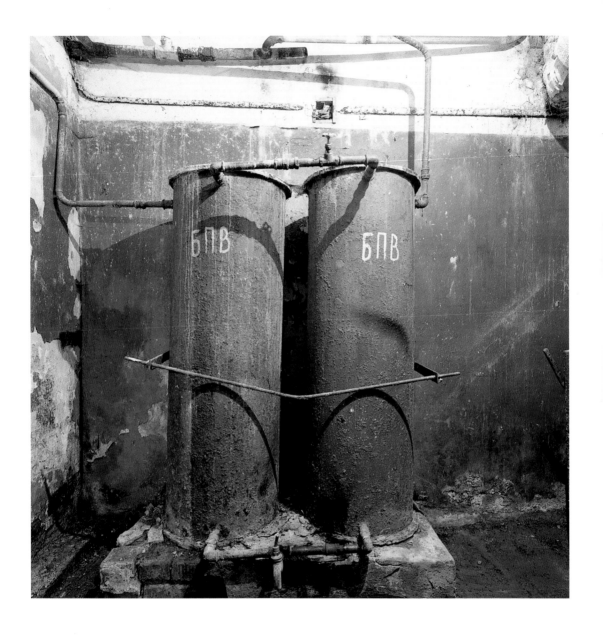

Bolshaya Bronnaya Street, Moscow, 2003

Jiaozhuanghu Village in China is about three hours outside Beijing and the site of a series of extensive esophageal tunnels that run under a farming community. They were built during the 1930s Sino-Japanese War as hiding sanctuaries for the farmers. The complex resembles a prairie dog village with its series of entrances and escapes, located under millstones, leading into barns and through kitchens. Currently, the tunnels are a tourist attraction in the middle of a rather desolate landscape.

.

.

.

.

.

.

.

.

.

.

.

.

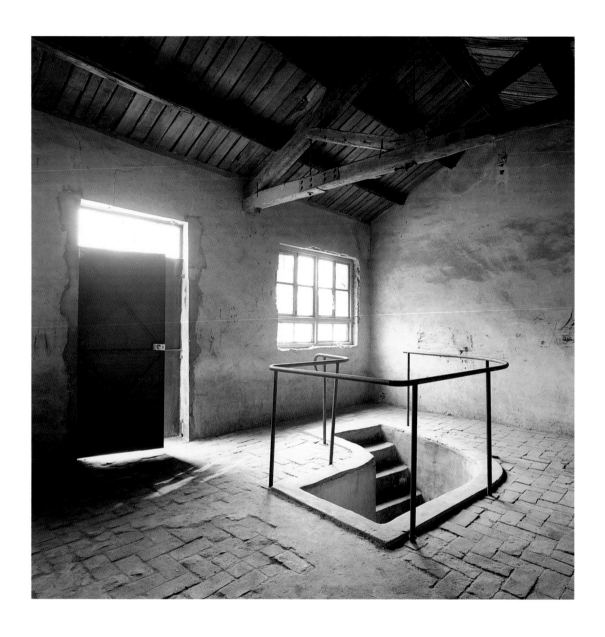

Jiaozhuanghu Village, China, 2003

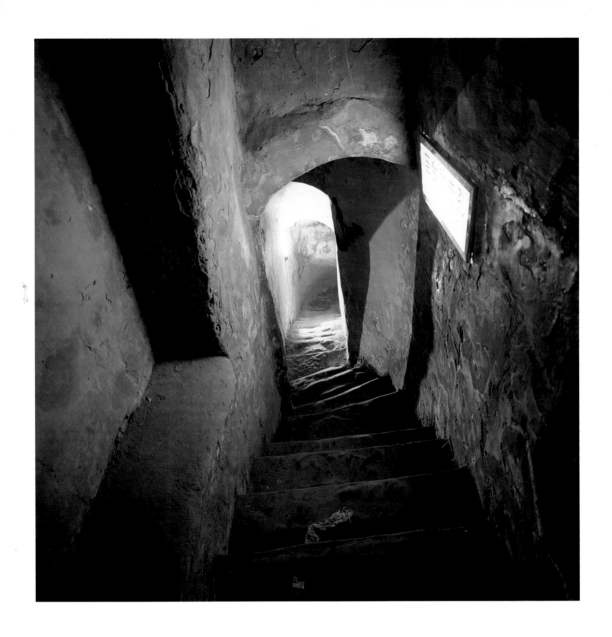

Jiaozhuanghu Village, China, 2003

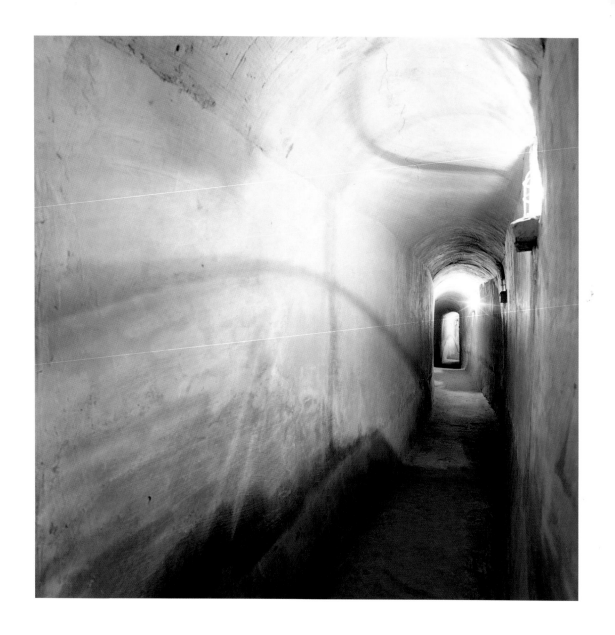

Jiaozhuanghu Village, China, 2003

Built in Conroe, Texas during the 1980s by Ling-Chieh "Louis" Kung, the nephew of Madame Chang Kai-Shek and an oil-tycoon, this shelter can house up to 1,500 people. It is 70 feet deep and 38,000 square feet in area, with a 27-foot-thick concrete ceiling. Until recently, the structure was complete with conjugal rooms, a jail, body bags, gun-slits, operating rooms, armor, and reinforced steel doors. Access is through two pagodas, which can be transformed into defensive centers. The shelter is presently being developed as a data storage center with secure underground data transmission and storage facilities by Jarvis Entertainment Group of Montgomery, Texas.

Texas is now the scene of a good deal of building of "B/C rooms" (biological and chemical shelters), which can be built at lower cost than a nuclear blast shelter. Biological and chemical rooms can be above ground, sealed with a positive air pressure venting system, and equipped with an air filtration system.

.

.

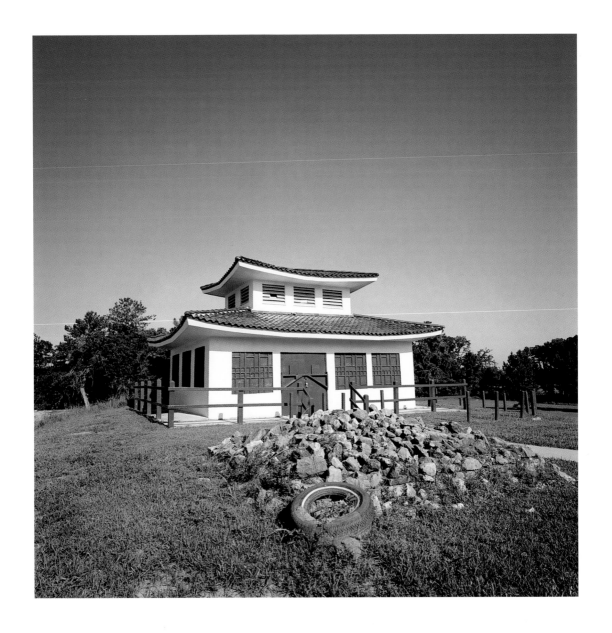

Conroe, Texas, 2003

SYSTEM

AIR HANDLER 2	FLOW		AIR HANDLER 2	NO FLOW
AIR HANDLER 3 HIGH SPEED	FLOW		AIR HANDLER 3 HIGH SPEED	NO FLOW
AIR HANDLER 3 LOW SPEED	FLOW		AIR HANDLER 3 LOW SPEED	NO FLOW
AIR HANDLER 1 CHILLED WATER	FLOW		AIR HANDLER 1 CHILLED WATER	NO FLOW
AIR HANDLER 2 CHILLED WATER	FLOW		AIR HANDLER 2 CHILLED WATER	NO FLOW
AIR HANDLER 3 CHILLED WATER	FLOW		AIR HANDLER 3 CHILLED WATER	NO FLOW

CONDENSING AND CHILLED WATER CONTROL SYSTEM

CONDENSING WATER PUMP 1 SELECT

CONDENSING WATER PUMP 2 SELECT

WATER CHILLER UNIT 1 SELECT

WATER CHILLER UNIT 2 SELECT

CONDENSING WATER PUMP P-1	FLOW		CONDENSING WATER PUMP P-1	NO FLOW
CONDENSING WATER PUMP P-2	FLOW		CONDENSING WATER PUMP P-2	NO FLOW
CHILLED WATER UNIT 1	FLOW		CHILLED WATER UNIT 1	NO FLOW
CHILLED WATER UNIT 2	FLOW		CHILLED WATER UNIT 2	NO FLOW

SHELTER CONTROL MODE SELECTOR

UNOCCUPIED MODE

PRE ATTACK MODE

TRANS ATTACK MODE

POST ATTACK MODE

SHELTER HUMIDITY CONTROLLED

SHELTER TEMPERATURE CONTROLLED

GENERATOR SELECTOR CONTROL SYSTEM

GENERATOR 1 SELECT

GENERATOR 2 SELECT

GENERATOR 1 HIGH TEMPERATURE	GENERATOR 2 HIGH TEMPERATURE
GENERATOR 1 LOW OIL PRESSURE	GENERATOR 2 LOW OIL PRESSURE
GENERATOR 1 OVER CURRENT	GENERATOR 2 OVER CURRENT
GENERATOR 1 LOCKED OUT	GENERATOR 2 LOCKED OUT

IF BIO. OR GAS THREAT DO NOT USE

FLOW
FLOW
FLOW
FLOW

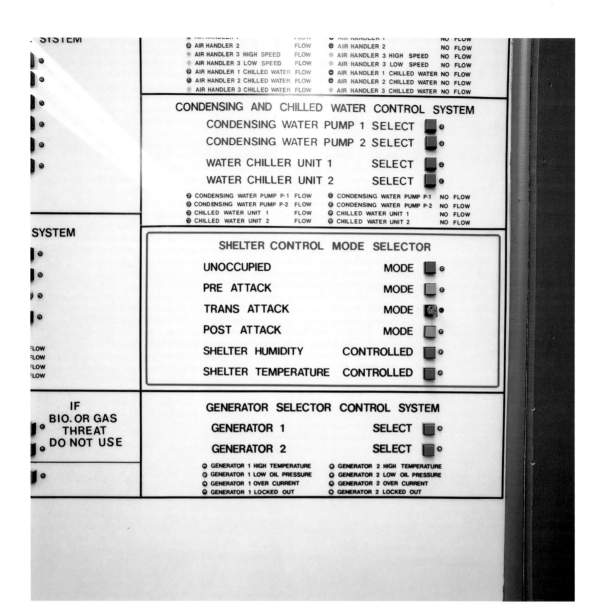

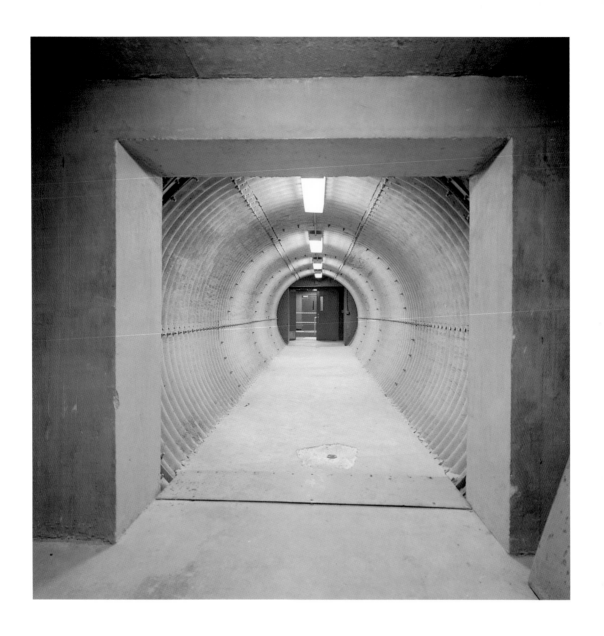

Conroe, Texas, 2003

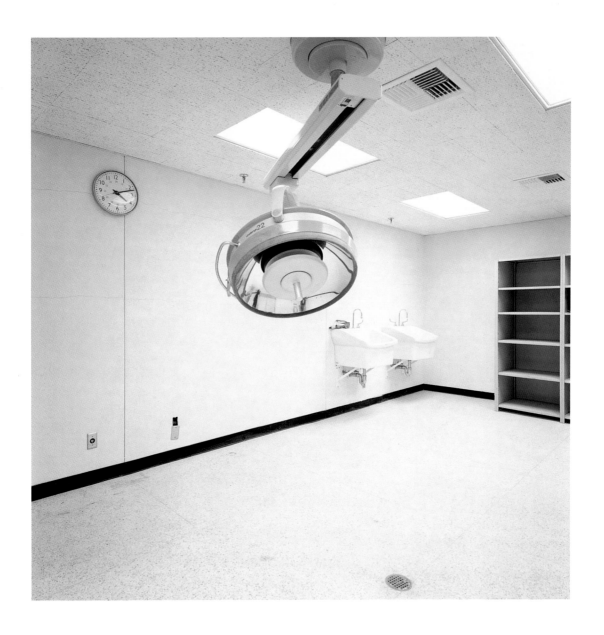

Conroe, Texas, 2003

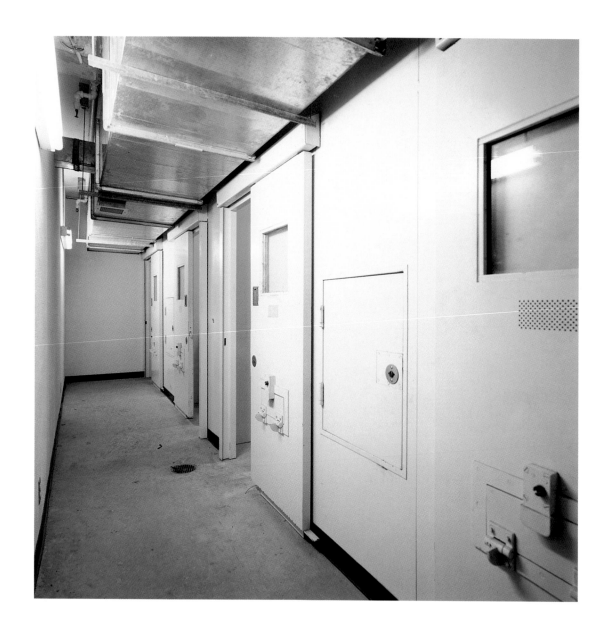

Conroe, Texas, 2003

This is the primary shelter complex for a group of Salt Lake City-area residents in remote San Pete County. As the land in this rural area is low-priced, the shelters built here are larger, some measuring up to fifty feet in length and ten feet in diameter. Located at least twenty feet below ground, the shelters, built in the late 1990s, are equipped with bunk beds that line the walls and have room for storage beneath the level floors. Each item in the shelter has been carefully chosen to ensure that no unnecessary airspace is occupied; more extensive supplies are available at a remote site. The volume of supplies is targeted to sustain isolated, independent life for a period of seven years. A Swiss-made air filter is capable of providing a flow of filtered air for several weeks or more.

.

.

.

.

.

.

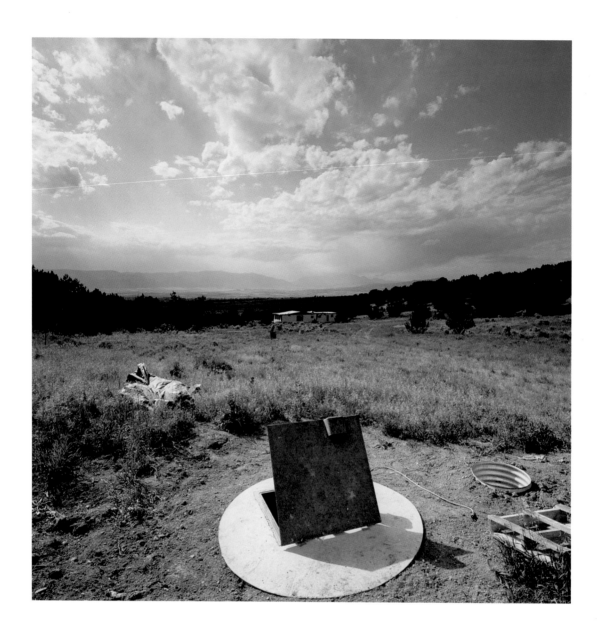

San Pete County, Utah, 2003

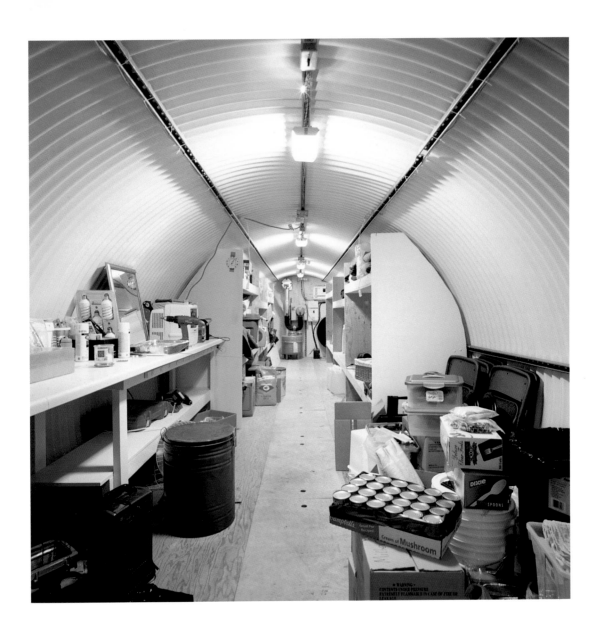

San Pete County, Utah, 2003

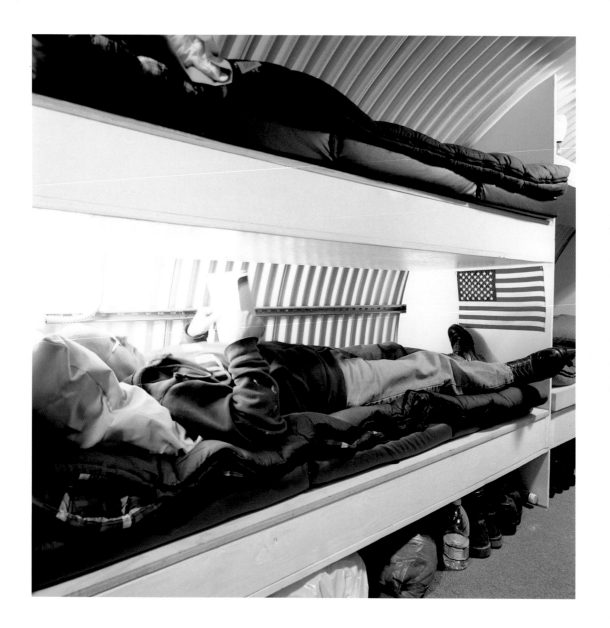

San Pete County, Utah, 2003

Built into a hillside in Santa Barbara,
California, near the botanical gardens, this
shelter from the early 1960s forms a semi-egg-
shaped dome, complete with a detailed wainscot.
Access is by a series of simple 2x4 wooden lad-
ders. There is no provision for power, sewage,
or light in this primitive shelter, an unusual
example of a blast or nuclear prioritized shelter.

.
.
.
.
.
.
.
.
.
.
.
.
.
.

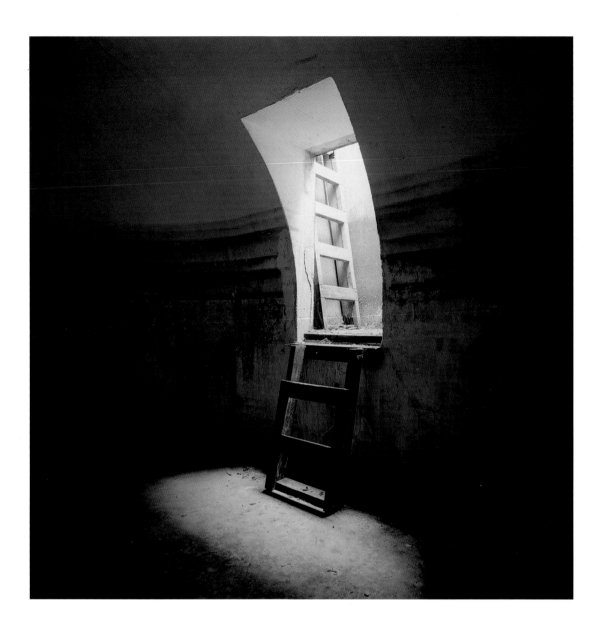

Santa Barbara, California, 2002

When people ask me, "How do you find these places?" it is a joy to show them the image of the Kelvedon Hatch "Secret Nuclear Bunker." The shelter, built in Essex during the 1950s to help improve Britain's air defense network, is today a tourist attraction. Its catacombs are preserved and populated with 1960s-era mannequins. The three-floored bunker complex had room for 600 people behind its blast-proof doors and contained its own BBC studio.

.

.

.

.

.

.

.

.

.

.

.

.

.

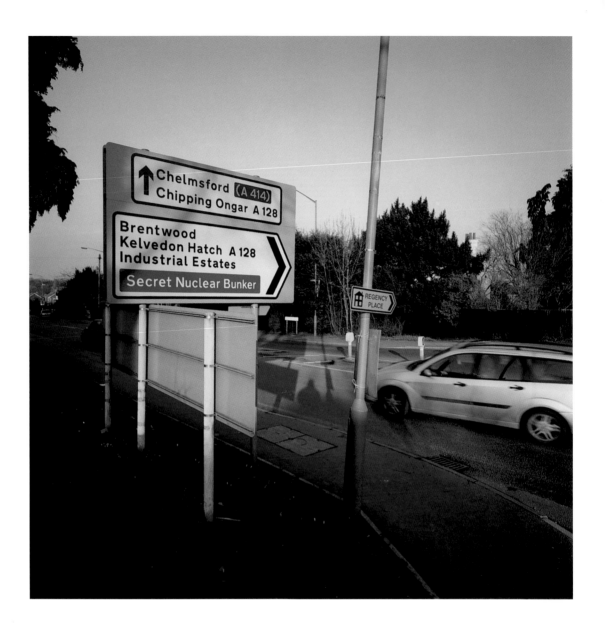

Kelvedon Hatch, Essex, England, 2002

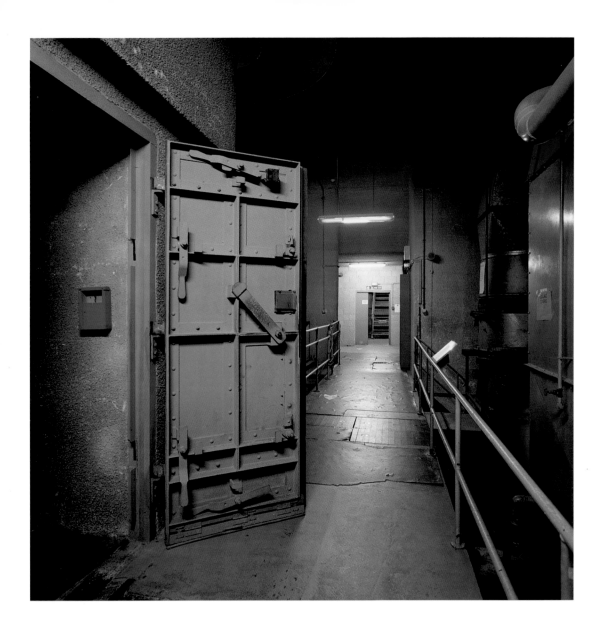

Kelvedon Hatch, Essex, England, 2002

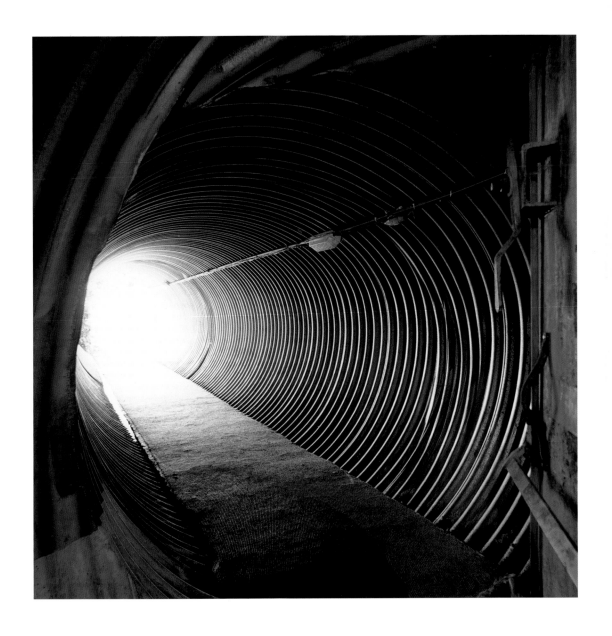

Kelvedon Hatch, Essex, England, 2002

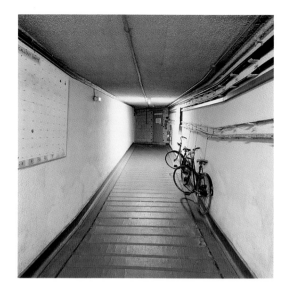
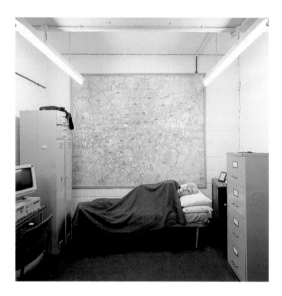

Kelvedon Hatch, Essex, England, 2002

Kelvedon Hatch, Essex, England, 2002

Allegedly, the Swiss can put 110 percent of their
population underground within two to six hours.
In the same vein, they can blow all their bridges
and tunnels in twenty minutes. This level of pre-
paredness was mandated by the federal government
in the 1970s when a law was passed that called
for protection (in a private or group shelter)
for every Swiss citizen. Almost all of the Swiss
shelters are fully stocked and ready to be
occupied within a few hours. Some serve as the
site of instruction on survival for high school
classes.

In Vitznau the site is outfitted for groups of
tourists who pay to spend a weekend in a World
War Two shelter. A group of Japanese tourists had
just vacated the site when these photographs were
taken.

.

.

.

.

.

.

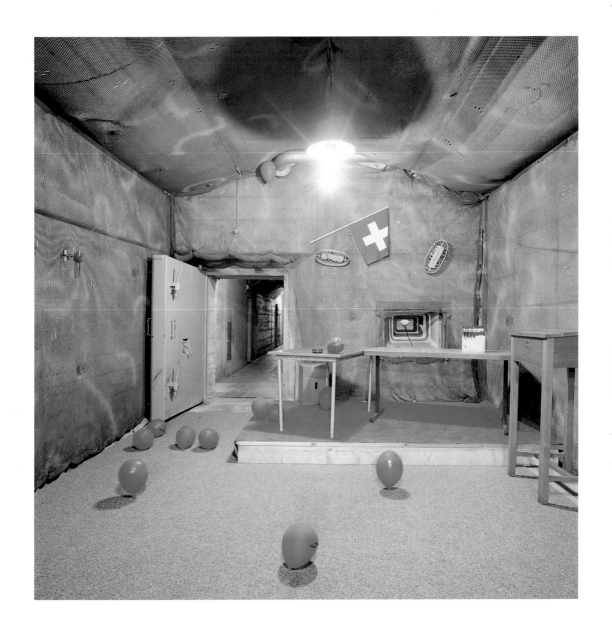

Vitznau, Switzerland, 2003

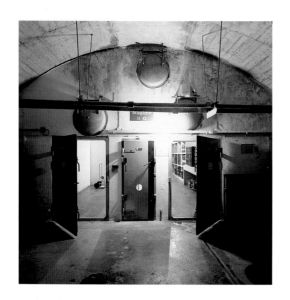 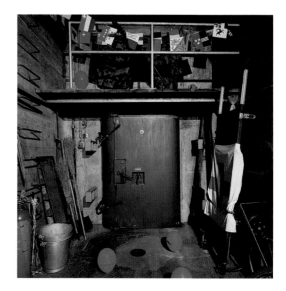

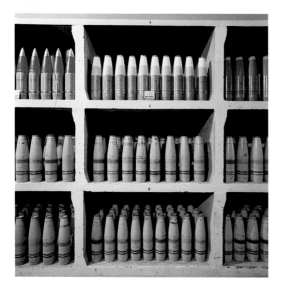 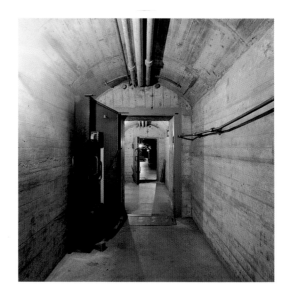

Vitznau, Switzerland, 2003

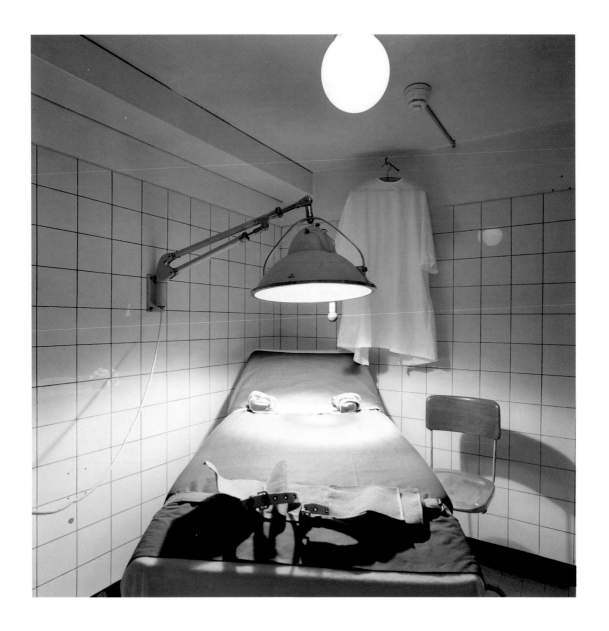

Vitznau, Switzerland, 2003

The World War Two shelters in London, built approximately two hundred feet underground, frequently shared access with the London subway, the Tube. This allowed over ten thousand people to enter the shelters somewhat covertly. There are at least ten of these sites still in existence in the London area. Currently, they are home to several data storage corporations such as Abbey Data Storage and Recall. Contrasting with shelters built for protection against a nuclear event, these sites were actually used repeatedly during World War Two.

.
.
.
.
.
.
.
.
.
.
.

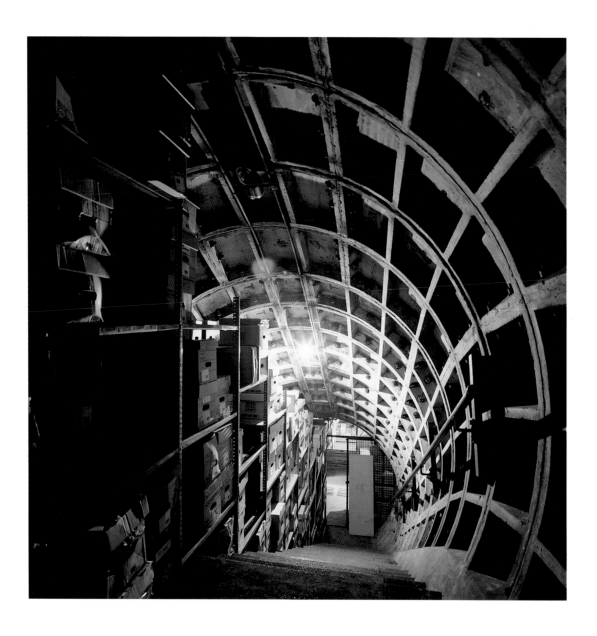

Abbey Data Storage, Bellsize Park, London, 2002

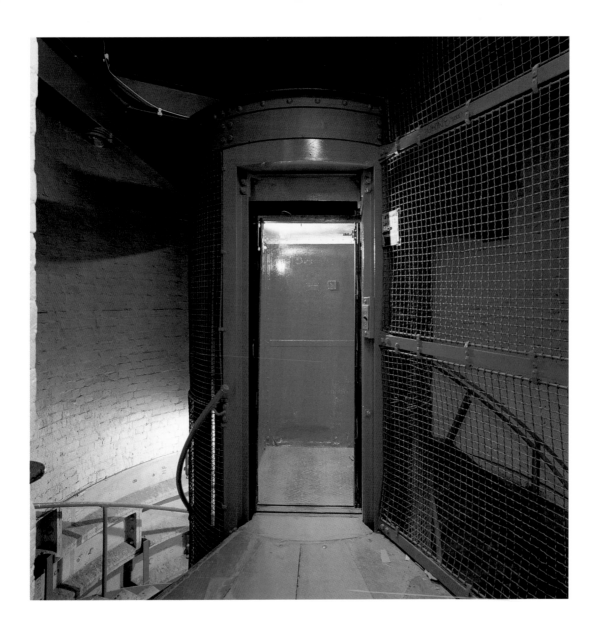

Abbey Data Storage, Bellsize Park, London, 2002

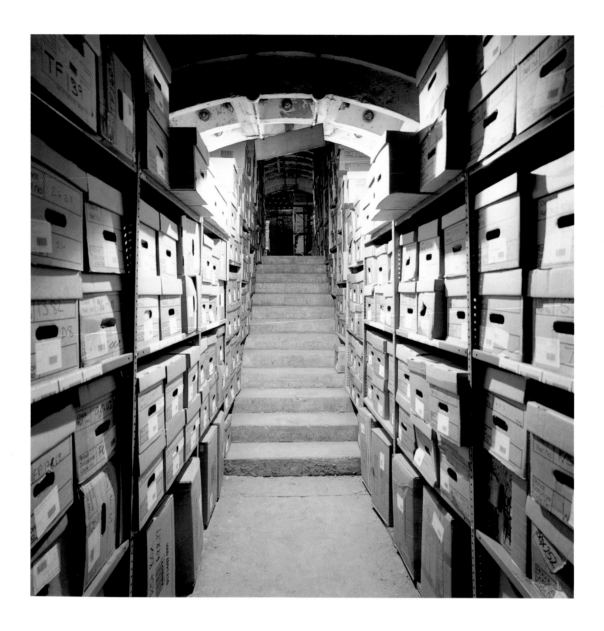

Abbey Data Storage, Bellsize Park, London, 2002

This is the Paddock, an alternative administrative center for Churchill and the Cabinet during World War Two. Churchill used the shelter, located in a north London suburb, only once, for a trial run. After the war, it served as a post office research facility and was then converted to a social club (with walls painted red). It has since been abandoned, but preserved for historical import. The white, fluffy mold on the ceilings and walls is at least an inch thick.

.

.

.

.

.

.

.

.

.

.

.

.

.

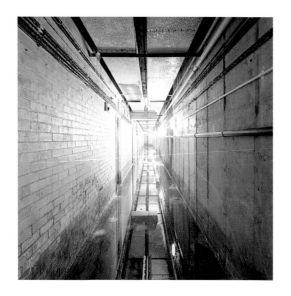

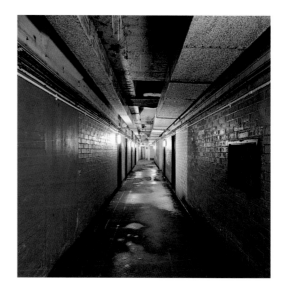

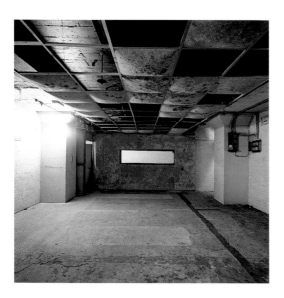

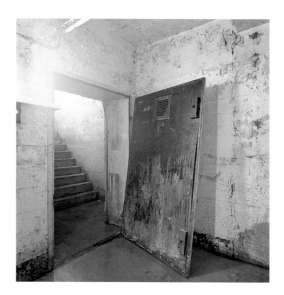

The Paddock, Neasden, London, 2002

The Paddock, Neasden, London, 2002

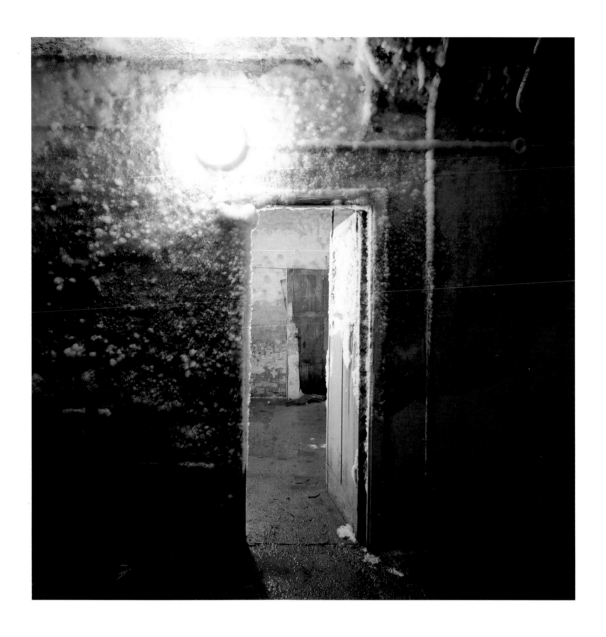

The Paddock, Neasden, London, 2002

The Strand stop is a portion of the Tube that
has been abandoned since the 1970s. During World
War Two the station was a temporary shelter for
thousands of people who would sleep on the plat-
form. Currently, the locale is used as a setting
for MTV video and fashion shoots. The elevators
are nonfunctional, although this is one of the
deepest stops in London.

.

.

.

.

.

.

.

.

.

.

.

.

.

.

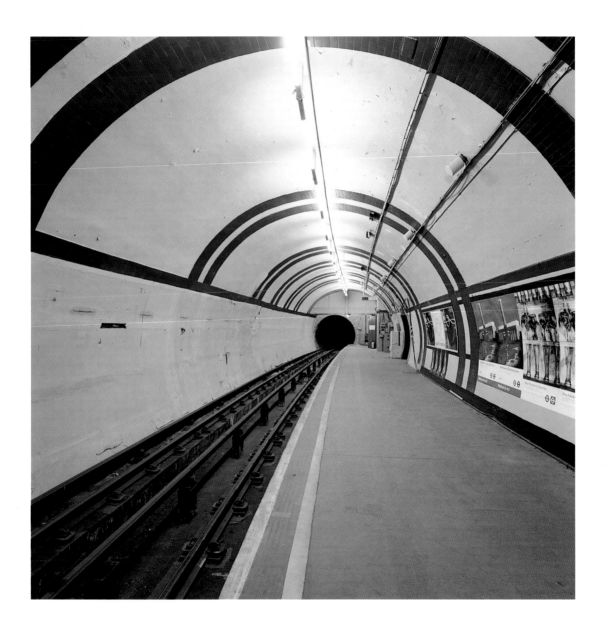

Strand Underground, London, 2002

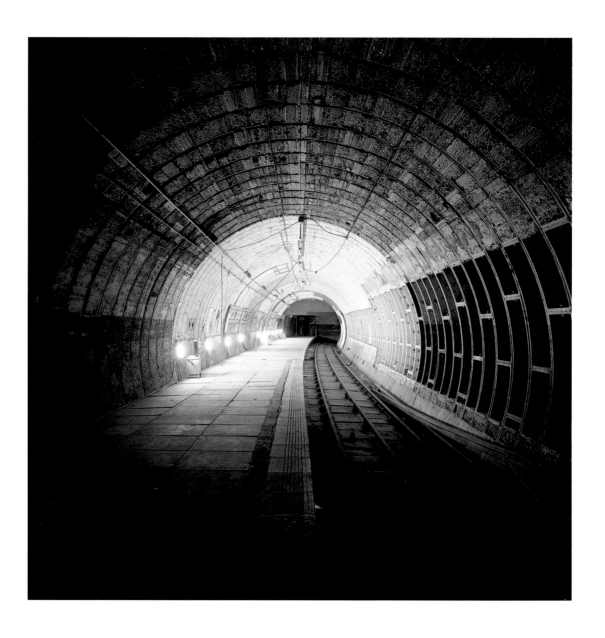

Strand Underground, London, 2002

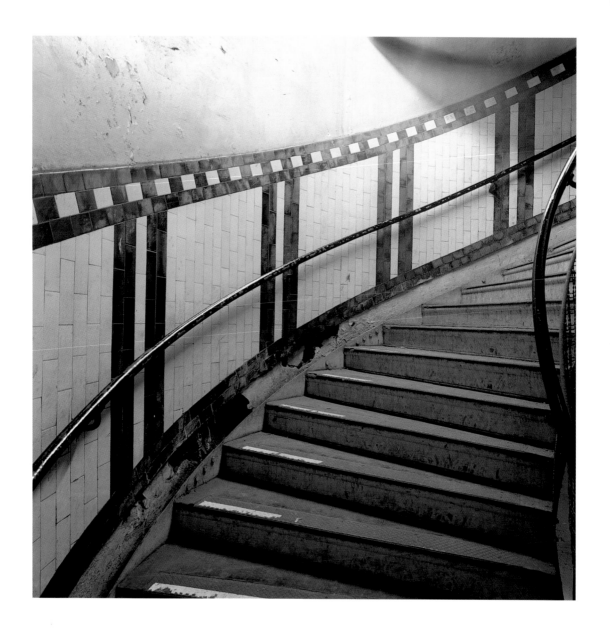

Strand Underground, London, 2002

Although thousands of commuters walk past them each day, few stop to notice the blast doors that can seal off many of the Moscow subway stations in an emergency. The subway stations, many of which doubled as shelters during World War Two, are among the masterpieces of Soviet architecture. Their escalators are so fast that subway employees (mostly women or pensioners) stand guard to observe passengers as they descend, ready to push the red emergency buttons if needed. While much of the architecture is classical, the walls are frequently decorated with murals depicting subjects of Soviet heroism. In a transition tunnel, I photographed a group of four Russian Chechnya War veterans who sang historical patriotic songs and asked for donations.

.

.

.

.

.

.

.

Opposite: **Mayakovskaya subway station, Moscow**
Above: **Belorusskaya subway station, Moscow, both 2003**

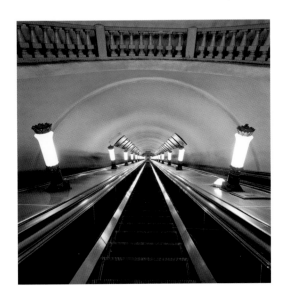

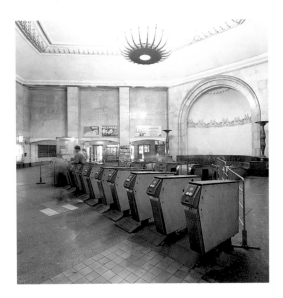

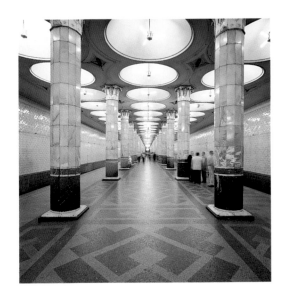

From top left to bottom right:
Komsomolskaya subway station, Moscow
Nevsky Prospect subway station, St. Petersburg
Ploshchad Revolutsii, subway station, Moscow
Kievskaya subway station, Moscow, all 2003

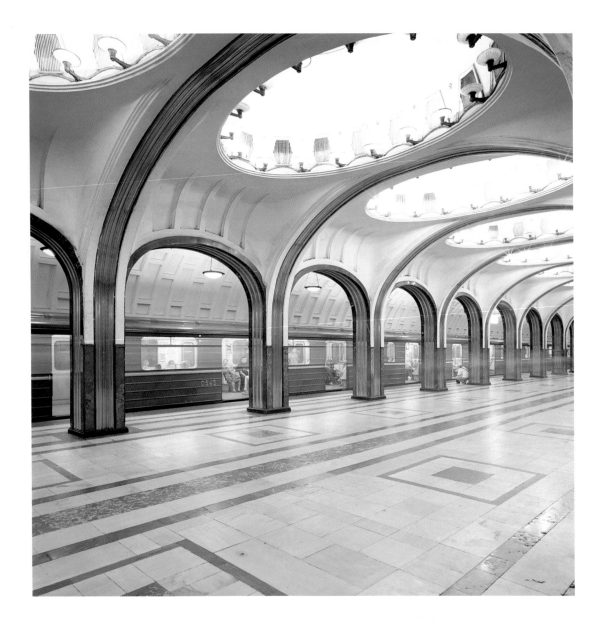

Mayakovskaya subway station, Moscow, 2003

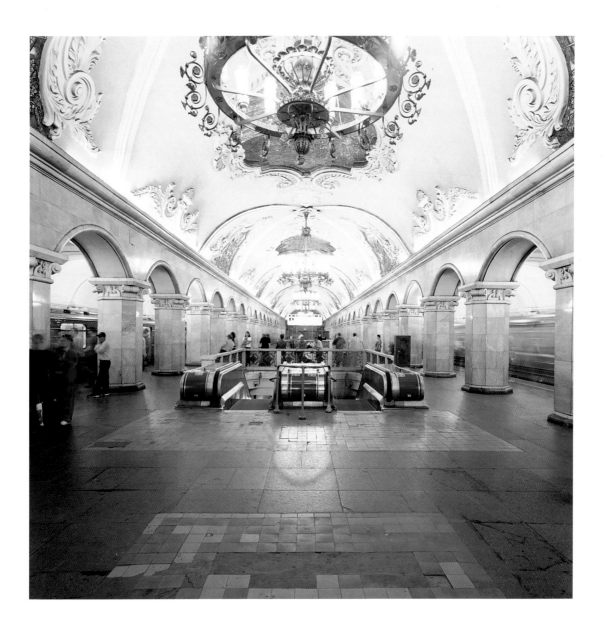

Komsomolskaya subway station, Moscow, 2003

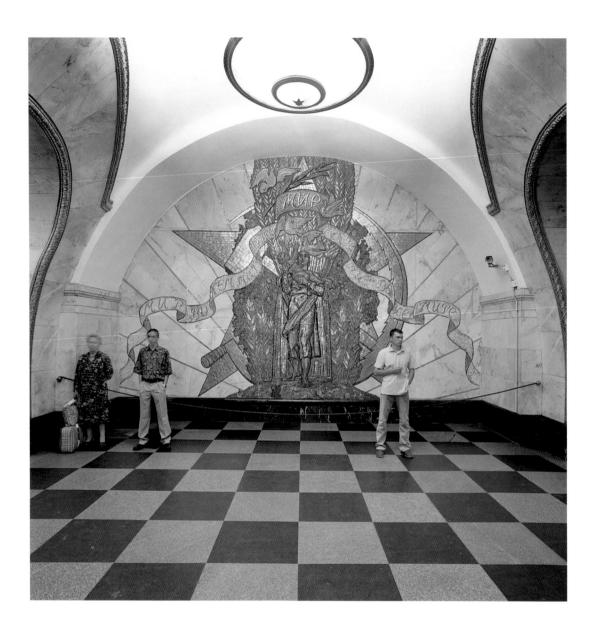

Novoslobodskaya subway station, Moscow, 2003

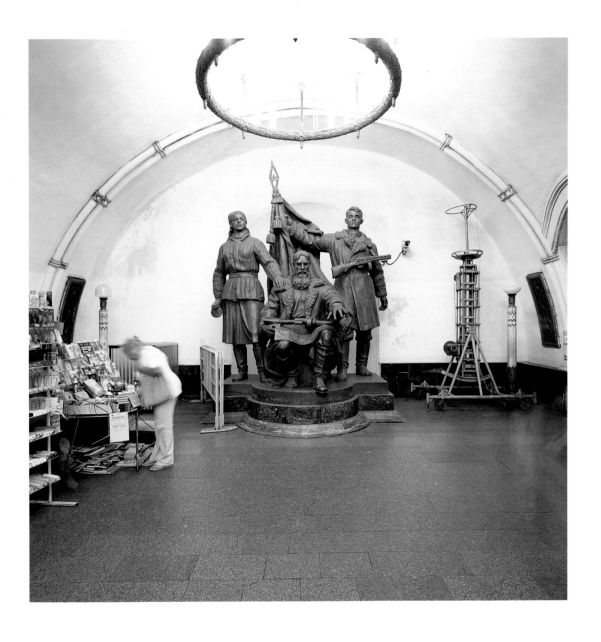

Belorusskaya subway station, Moscow, 2003

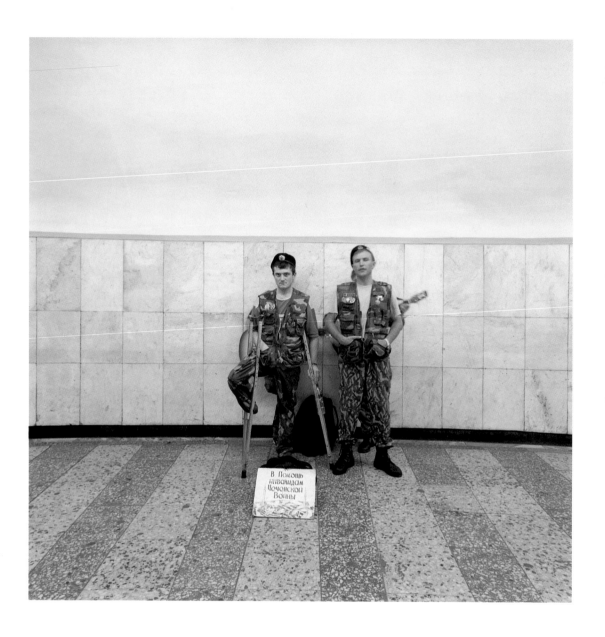

Chechnya war veterans, Moscow, 2003

The elite hotel The Greenbriar in White Sulphur Springs, West Virginia, has also been home to the emergency NBC (nuclear/biological/chemical) shelter of the US Congress since the early 1960s. For thirty years this remained top secret: hotel guests walked by flocked wallpaper disguising thirty-ton blast doors, never suspecting the hotel's double function. The facility was maintained by a team of fifteen technicians who were allegedly maintaining the cable TV system.

Located about five hours from Washington, D.C., this site demanded some advance notice to be occupied. It was projected to hold 1,800 people, and its facilities included chambers for the Senate and the House. The secret was exposed when the Washington Post reported on the shelter in 1992.

.

.

.

.

.

.

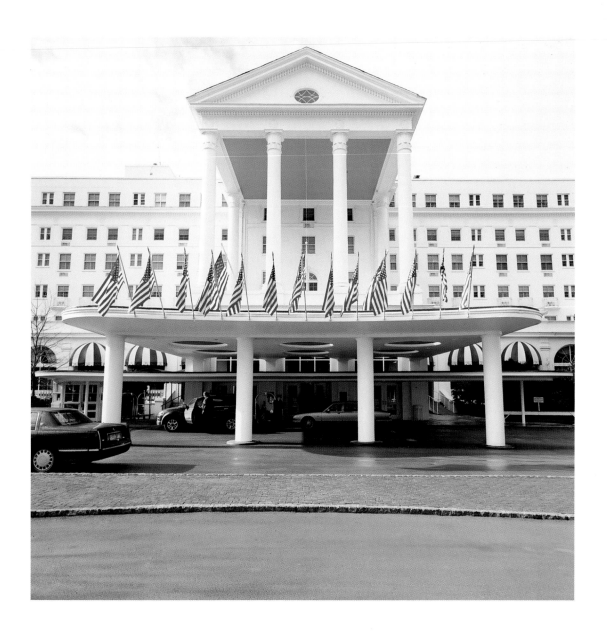

Greenbriar, White Sulphur Springs, West Virginia, 2002

Greenbriar, White Sulphur Springs, West Virginia, 2002

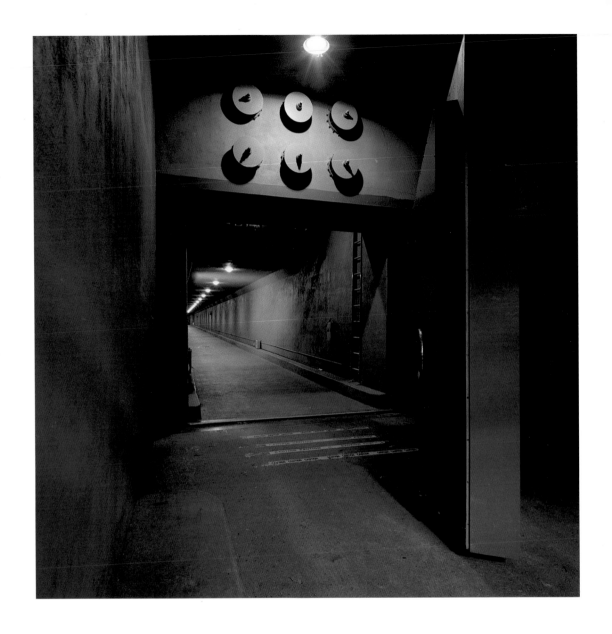

Greenbriar, White Sulphur Springs, West Virginia, 2002

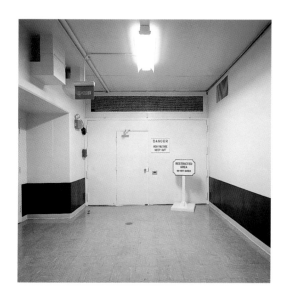

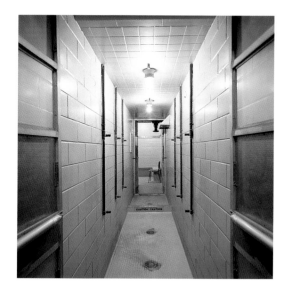

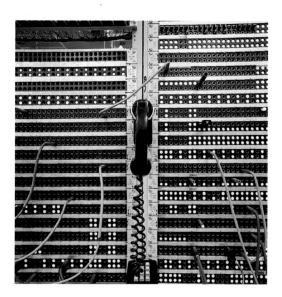

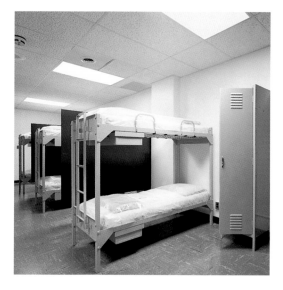

Greenbriar, White Sulphur Springs, West Virginia, 2002

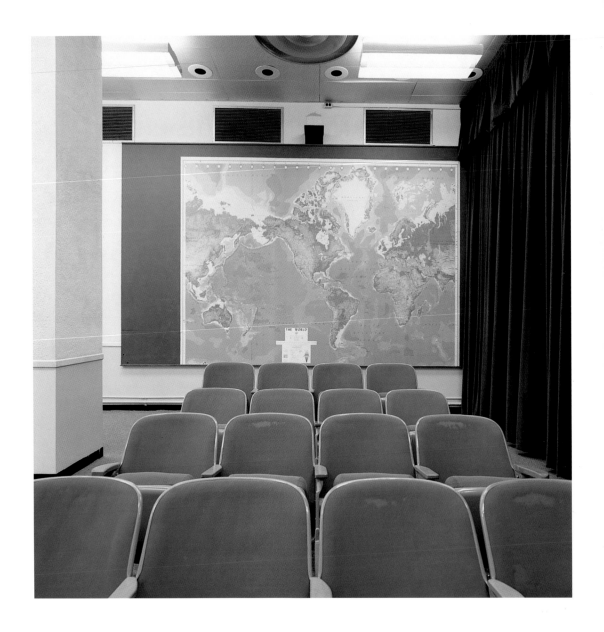

Greenbriar, White Sulphur Springs, West Virginia, 2002

Supposedly, Beijing's Underground City, built between 1969 and 1979 in response to Sino-Soviet tension, can hold up to 350,000 people. The tunnel complex used to house not only emergency dormitories, but included amenities such as barbershops and cafeterias. All doors were equipped with seal gaskets for protection against biological or chemical contamination.

Now partially abandoned, the tunnels open randomly into retail paper shops, Oriental rug stores, and Buddhist shrines, and are frequently used by shopkeepers as additional storage rooms. Underground City has become an offbeat tourist attraction and is in some state of disrepair. It will probably be closed before the 2008 Olympics.

.

.

.

.

.

.

.

.

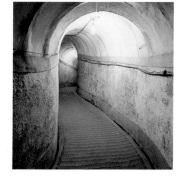

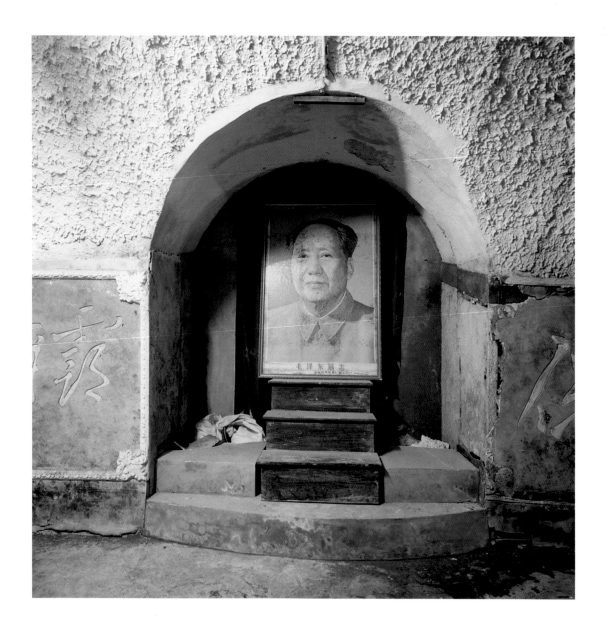

Underground City, Beijing, 2003

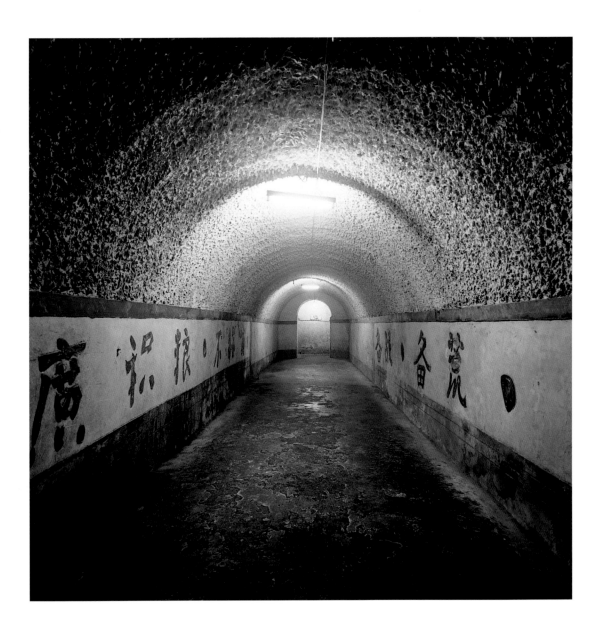

Underground City, Beijing, 2003

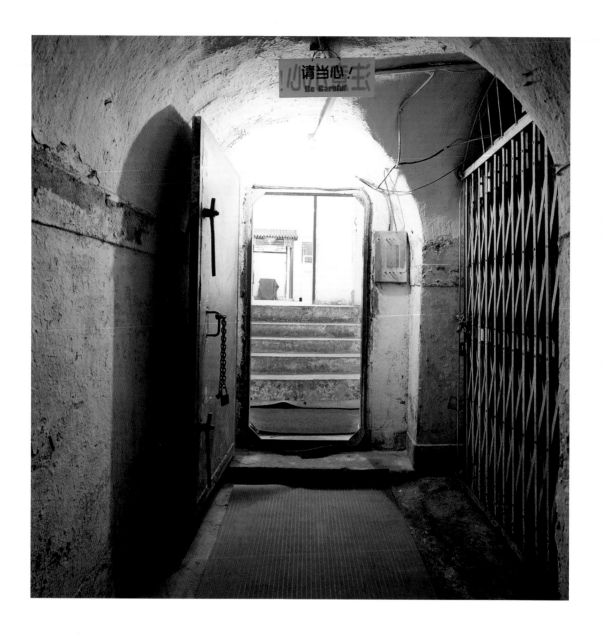

Underground City, Beijing, 2003

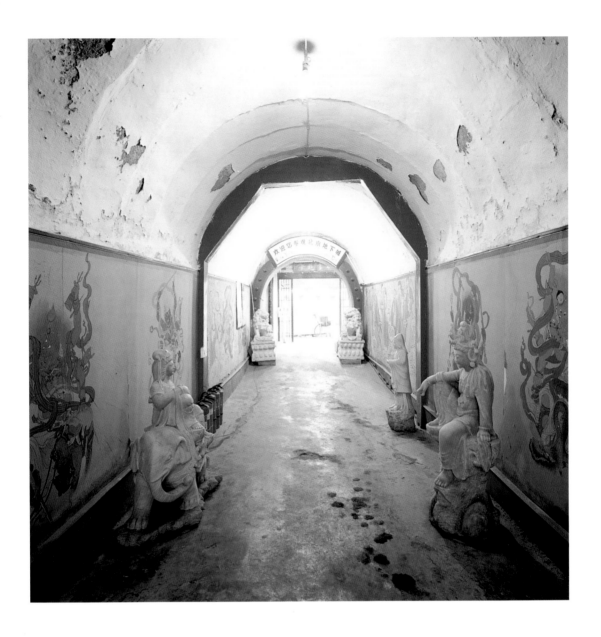

Underground City, Beijing, 2003

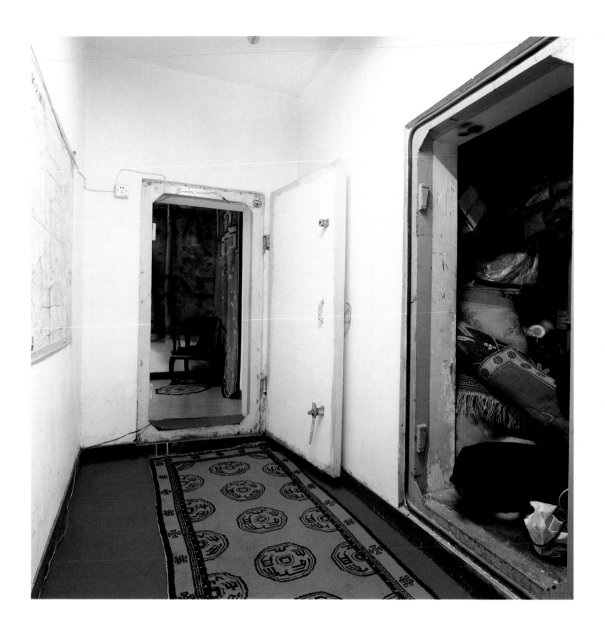

Underground City, Beijing, 2003

This shelter, located near the second-largest air
base in the Pacific during the Vietnam War,
served as a Viet Cong hospital. After the war, it
was converted into a shrine. The light falling in
through the ceiling is the result of US bombing
of the bunker.

.

.

.

.

.

.

.

.

.

.

.

.

.

.

.

.

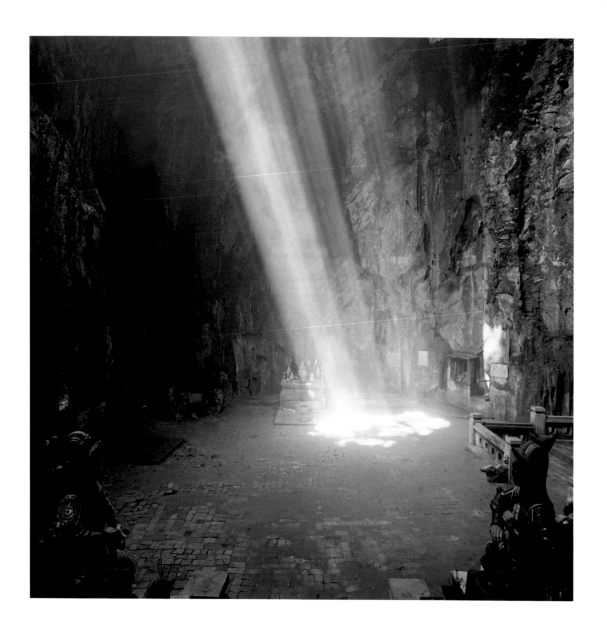

Marble Mountain, Danang, Vietnam, 1997

The ancient town of Acca in northern Israel was made into a large fortress during the first Crusade (1095-1100), serving as one of the centers for the Christian Crusaders. The inner walls of this tunnel complex acted, by an odd twist of fate, as a hiding place for Muslims during the second Crusade.

-
-
-
-
-
-
-
-
-
-
-
-
-
-
-
-

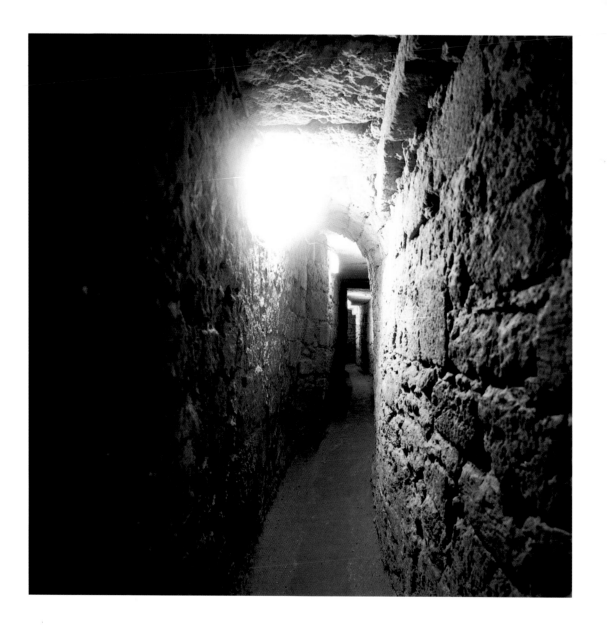

Acca, Israel, 1999

This five-story underground complex in Cappodocia, Turkey, was built by the Hittite civilization, a people that settled in this area around 2,000 BC. Anyone entering these caves had to stoop over, leaving their backs exposed. People hiding in the caves would use a parallel tunnel to come upon the invaders from behind and attack them from the rear. The complex included communal rooms for cooking; smoke was released upward through a series of lava rocks that dissipated the smoke and did not draw any attention to the site. Early Christians used the complex of tunnels to hide from the Roman armies.

.

.

.

.

.

.

.

.

.

.

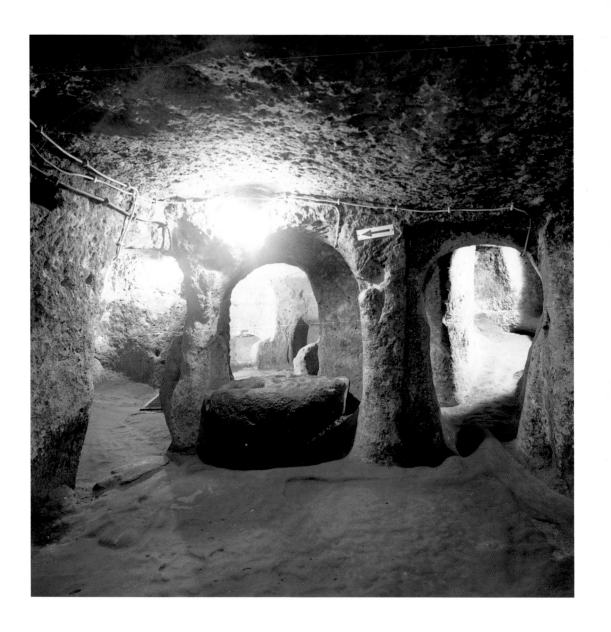

Hittite Caves, Cappodocia, Turkey, 1999

A new shelter is being installed in the Salt Lake City area. Taking a drain-pipe form, this shelter is fifty feet long and ten feet in diameter. Its construction, including the installation of air filters and airlocks, costs approximately $1,000 per linear foot and can be completed within three to four days. A shelter that is to be reasonably effective has to be deep enough to maintain a constant temperature of forty-eight to fifty-two degrees Fahrenheit. Shelters that are at shallower depths are of limited effectiveness.

.

.

.

.

.

.

.

.

.

.

.

.

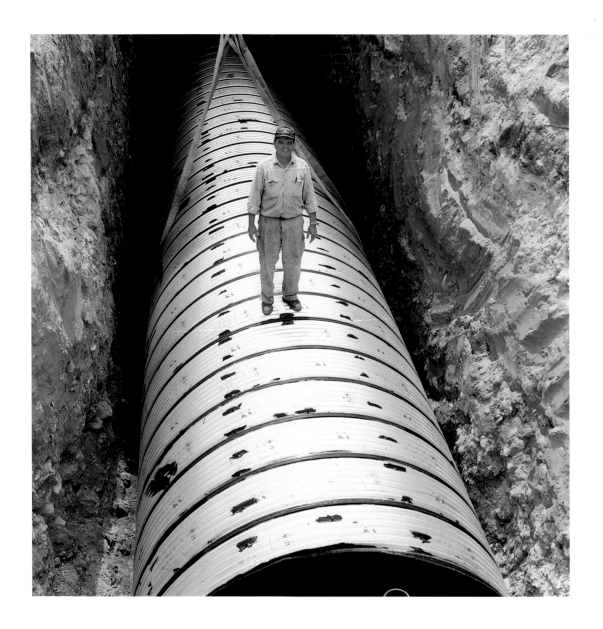

Suburban Salt Lake City, Utah, 2002

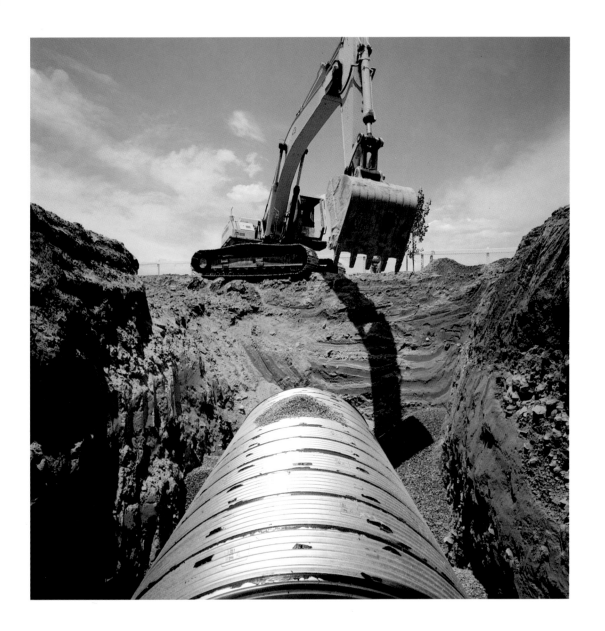

Suburban Salt Lake City, Utah, 2002

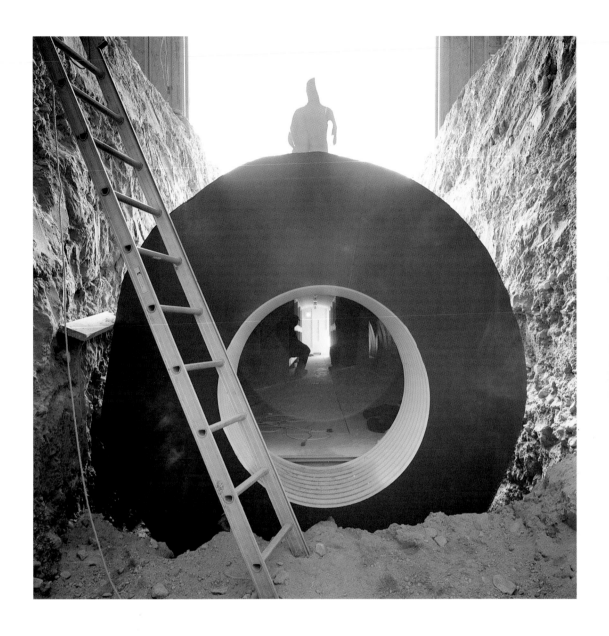

Suburban Salt Lake City, Utah, 2002

This subterranean building in Moscow was built as a bomb shelter for the residents of a nearby apartment complex during the cold war. In the early 1980s it was used as a KGB listening post to keep some of the same residents under surveillance. Some of the rooms still contain extensive old-fashioned telephone switchboards. Gas masks dot the underground landscape. The shelter has in recent years become a casual hangout for teenagers, who hold parties in this isolated and quiet locale.

.

.

.

.

.

.

.

.

.

.

.

.

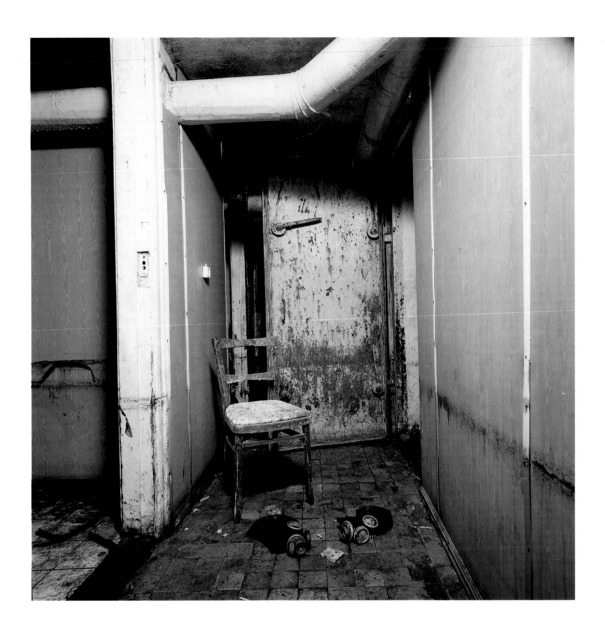

Apartment complex shelter, near Bellyruska Metro, Moscow, 2003

Moscow State University is situated in one of Moscow's most significant skyscrapers. Some thirty-six stories high, at 787 feet, the neoclassical edifice was the tallest building in Europe until 1988. Underneath this tower is a multilevel abandoned shelter, built in the early 1950s. Originally, this maze of underground rooms could house thousands of students. Portions of it are now used to store geological records and specimens from expeditions twenty years past. Some of the fluorescent lights in the rooms still function. Other parts of the shelter are flooded.

I accessed the site, after security patrols had passed, by descending through a narrow opening down a fourteen-foot-deep shaft with repelling ropes.

.

.

.

.

.

.

.

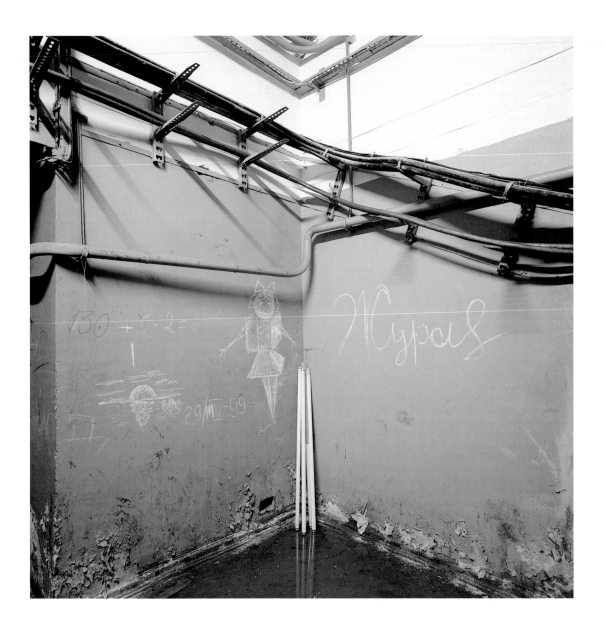

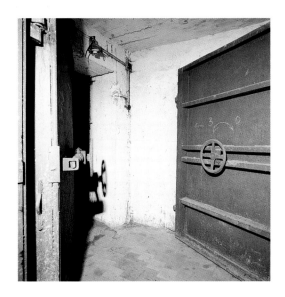

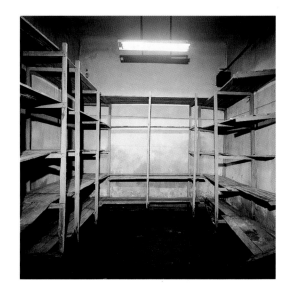

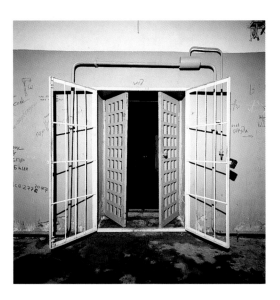

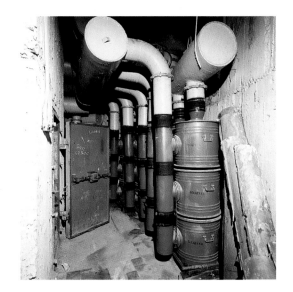

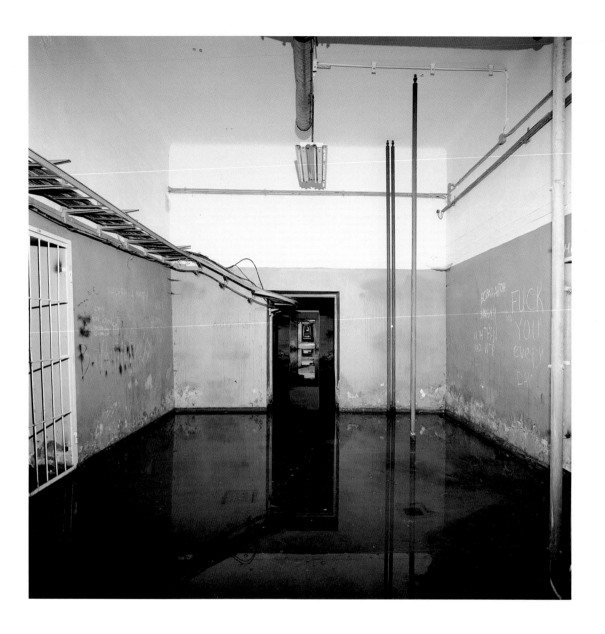

Moscow State University, Moscow, 2003

The Kotelnicheskaya apartment building is one of Moscow's so-called "seven sisters." Built during the 1950s Stalinist era, these multi-tiered, neo-classical skyscrapers ring the city. Although similar in design, they each serve a distinct purpose, holding apartment houses, hotels, government ministries, and the prestigious Moscow State University (see preceding pages). All of these heavily populated buildings include elaborate shelters below.

-
-
-
-
-
-
-
-
-
-
-
-
-

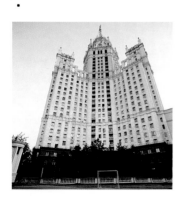

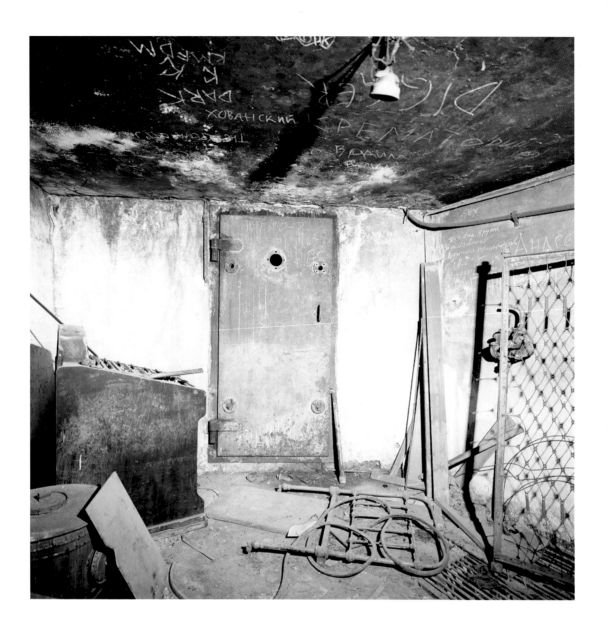

Kotelnicheskaya apartment building, Moscow, 2003

The discs that are produced in this factory near
Zurich are the tops of air filters. Contemporary
Switzerland has a uniform building code for
shelters. While individuality can be celebrated
in the shelter by the color of paint on the
door frame, each door must be made of reinforced
concrete and be of a specific size, shape, and
weight.

The blast-proof doors and the filtration
system on the following spread were shot in
various "active" (and prepared) community shelters
in Switzerland, most of them outside of Zurich.
The exterior doors are triple-lock monsters,
while interior spaces are equipped with simple
steel doors.

.

.

.

.

.

.

.

.

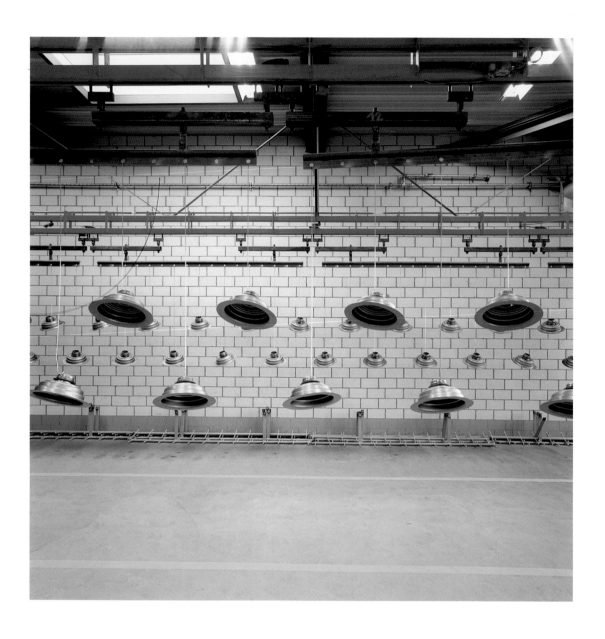

Andair AG, near Zurich, Switzerland, 2003

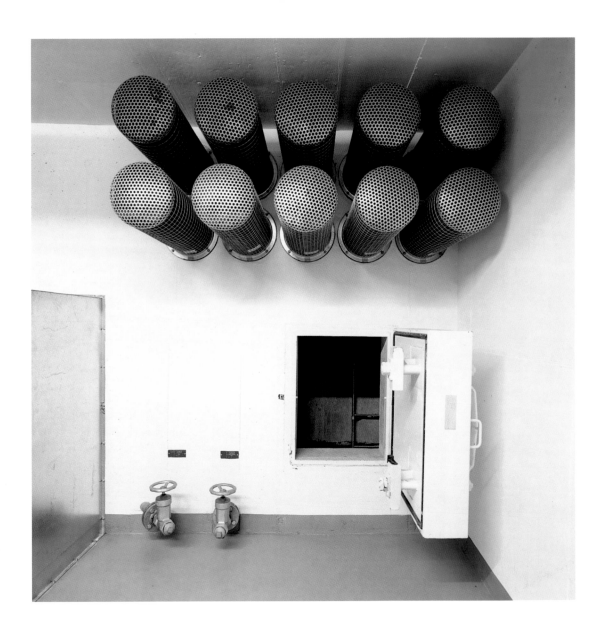

Public shelter, near Zurich, Switzerland, 2003

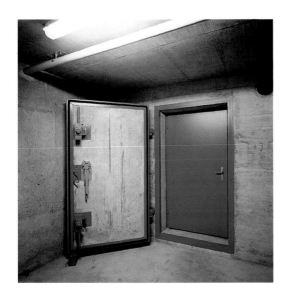

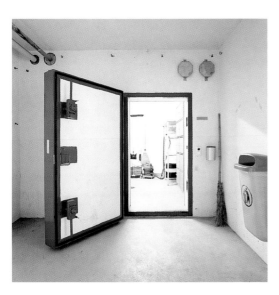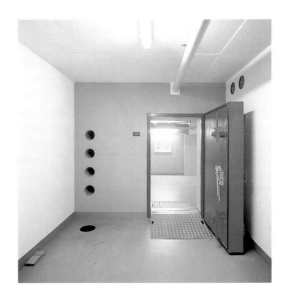

Public shelters, near Zurich, Switzerland, 2003

The proud owner of this new single-family residence in Switzerland shows off his shelter. He is standing in front of his (Andair-manufactured) air filtration system with the escape hatch on the right. The small shelter, equipped with provisions and odd furniture, is the basic structure in Swiss homes as required by federal building codes.

.

.

.

.

.

.

.

.

.

.

.

.

.

.

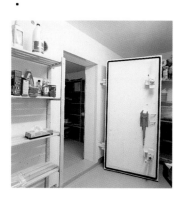

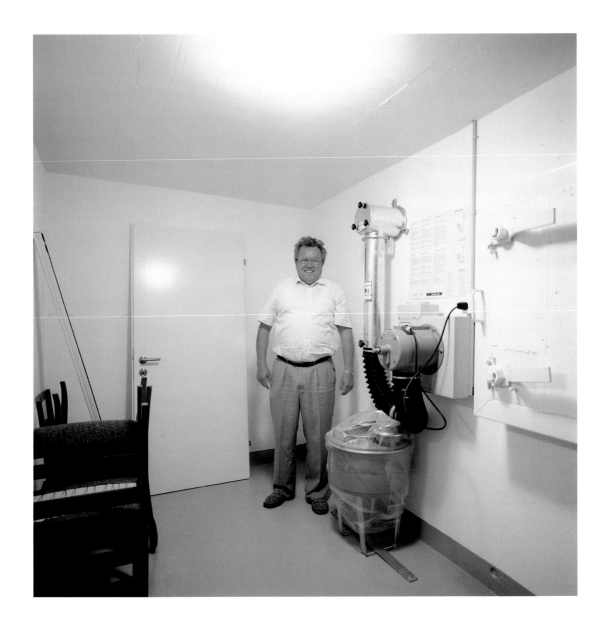

Near Andelfingen, Switzerland, 2003

This decentralized governing facility and civilian shelter in Cambridge, England, was built in 1953 and expanded in the 1960s. The hardened concrete structure is divided into two portions with different levels of wall thickness: atomic and nuclear (protection against hydrogen bombs).

The love of the British for the pastoral countryside is brought into this shelter in the form of calendar art placed on bulletin boards. The contrast between the beauty of the landscapes and the danger symbolized by the shelter is brought to a further level of paradox by the posted warnings of asbestos contamination. The shelter is due for demolition in 2004.

.

.

.

.

.

.

.

.

.

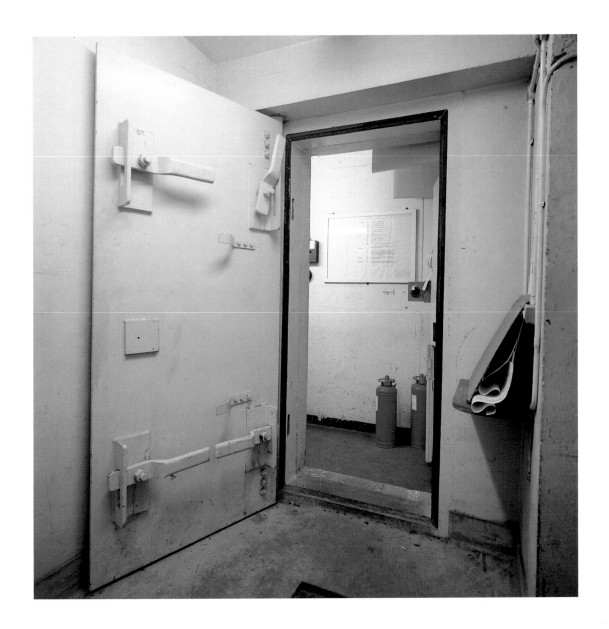

DEFREK, Cambridge, England, 2002

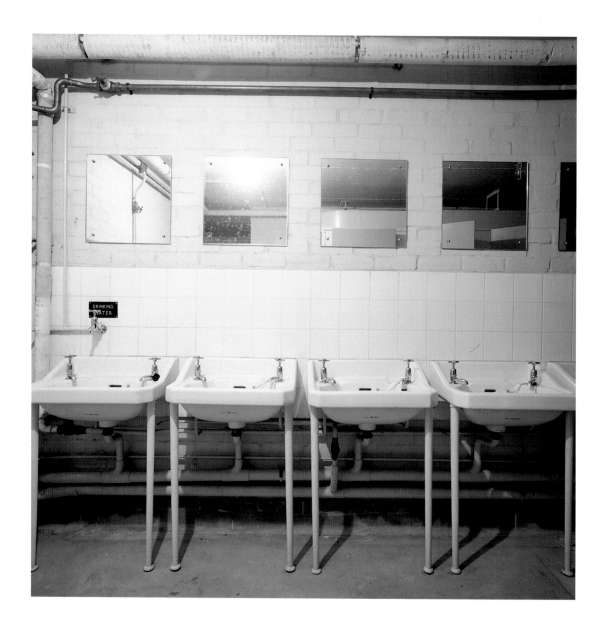

DEFREK, Cambridge, England, 2002

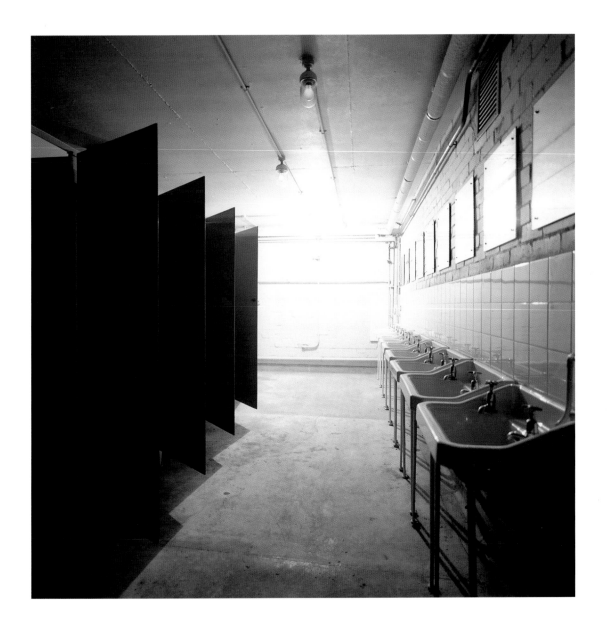

DEFREK, Cambridge, England, 2002

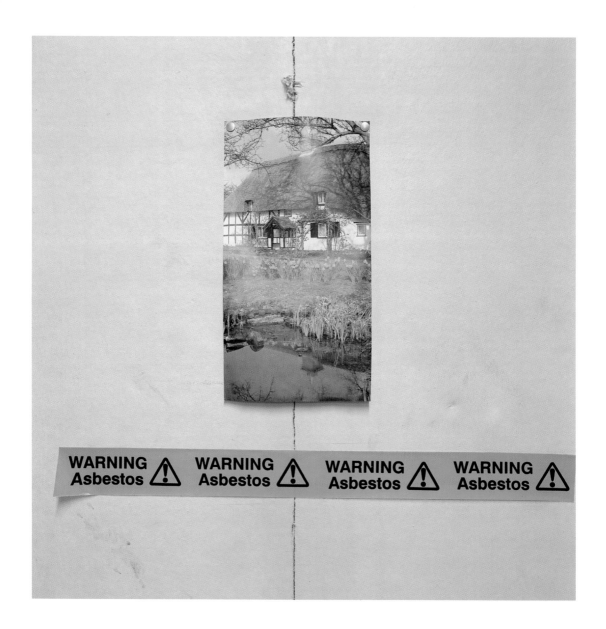

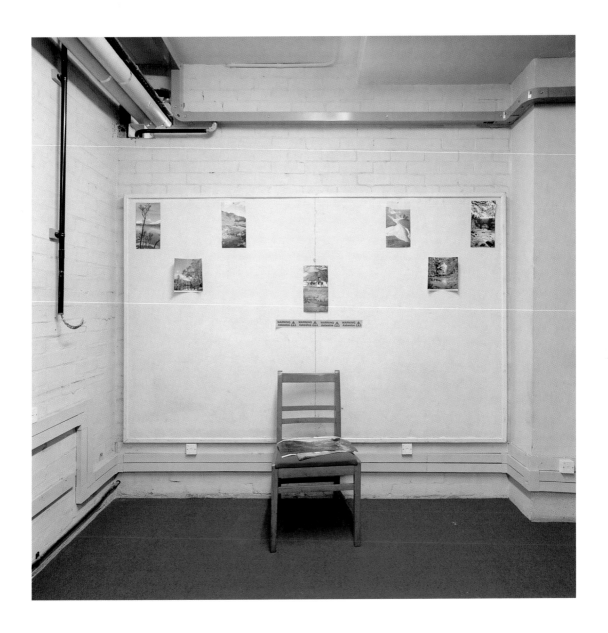

DEFREK, Cambridge, England, 2002

This group shelter was built between 1961 and 1962 with the combined resources of many of the University of California Lawrence Livermore National Laboratory scientists who assisted in the development of nuclear weapons. About twelve families—almost all of whom have since moved away or died—contributed to the construction of this shelter, each owning a sleeping area off the main community rooms. The structure is now used for storage by the single family remaining. A nineteen-year-old girl recently held a Halloween party in the structure.

The shelter's entry door was purchased from a marine salvage yard. Waterproof doors such as this one are prevalent in many shelters world-wide; it is assumed that, being waterproof, they can also withstand chemical or biological incidents.

.

.

.

.

.

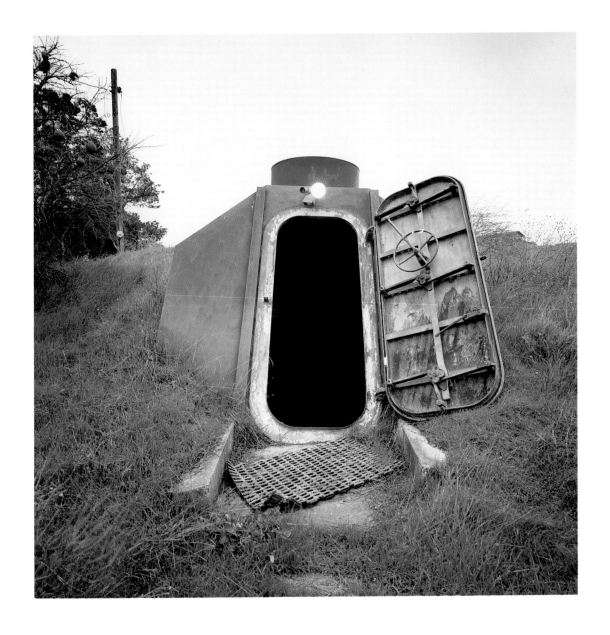

Livermore, California, 2002

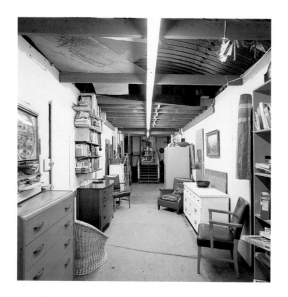
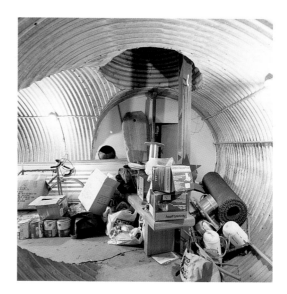
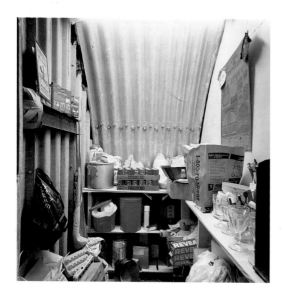
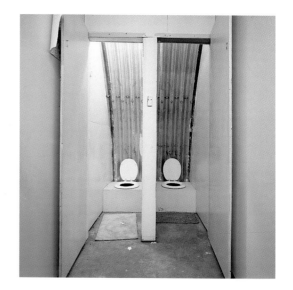

Livermore, California, 2002

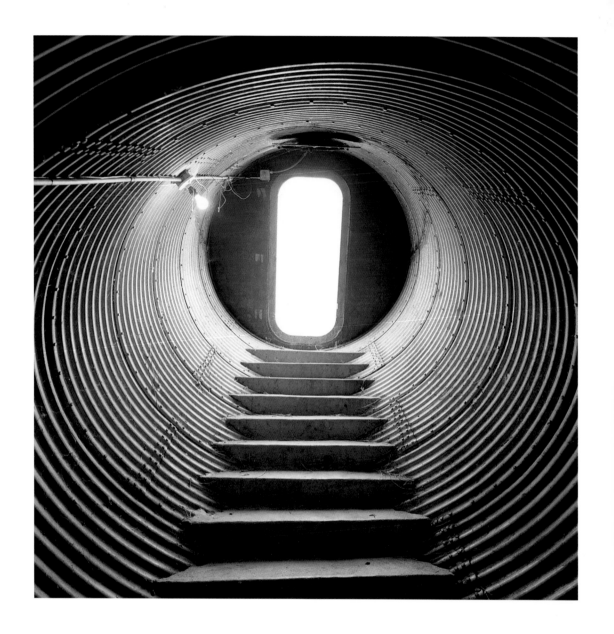

Livermore, California, 2002

"The Trendy Griboyedov Club" (Griboyedov is the last name of a famous Russian writer — Pushkin's contemporary — who was murdered by an angry mob in Persia when he worked at the embassy in Tehran) in St. Petersburg, Russia formerly served as a shelter for a nearby factory. The space is now divided into bar, dance floor, and DJ areas. Although the ventilation system was adapted to the current use, there is an amazing quantity of smoke in the club on weekend nights.

.

.

.

.

.

.

.

.

.

.

.

.

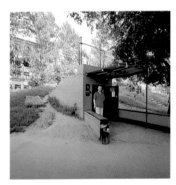

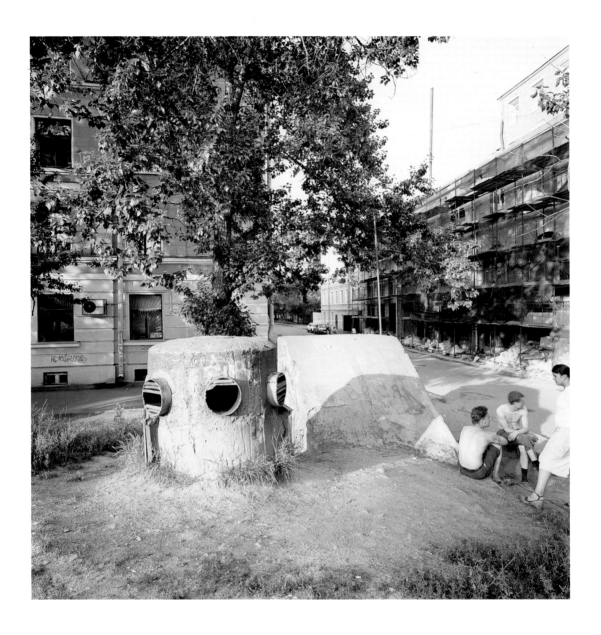

"The Trendy Griboyedov Club," St. Petersburg, Russia, 2003

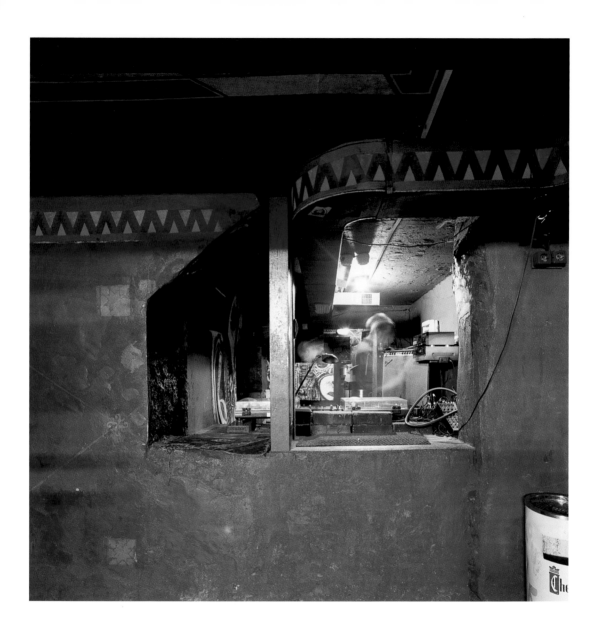

"The Trendy Griboyedov Club," St. Petersburg, Russia, 2003

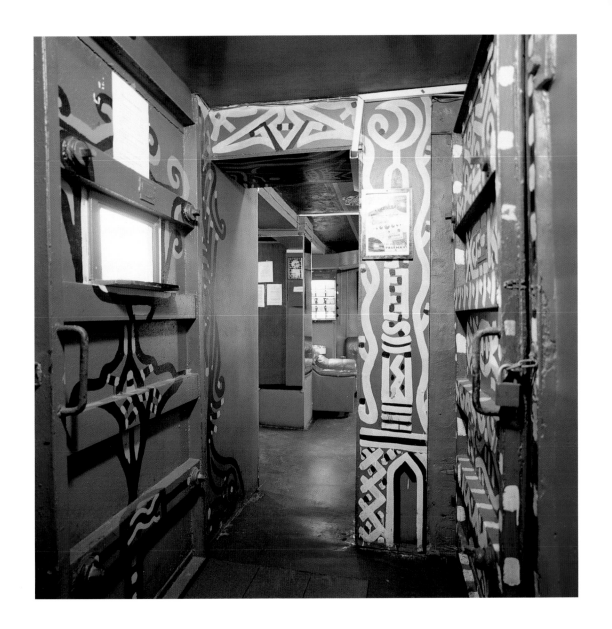

"The Trendy Griboyedov Club," St. Petersburg, Russia, 2003

This group shelter near the Emigrant Mountains in Montana, located a few hours from Yellowstone National Park, was built in 1989 by a group of about 130 people. The Web site (www.nodoom.com) hosted by Phillip Hoag, the administrator of the shelter, alludes to an affiliation with the Elizabeth Clare Prophet group, but the main reason for construction was the proximity of the Intercontinental Ballistic Missile fields in eastern Montana. The shelter has several diesel generators, decontamination rooms, observation towers, a full machine shop, communal cooking and recreation areas, as well as individual bedrooms. The observation tower is equipped with tank periscopes that can be used to observe what is going on above ground. While there was an unusual effort put into creating this tower, there is currently no armament within the shelter.

Although many group shelters such as this one are outfitted with enough provisions to ensure survival for several years, they are not quite operational. It might take days to weeks to pre-pare these shelters for habitation in an emergency.

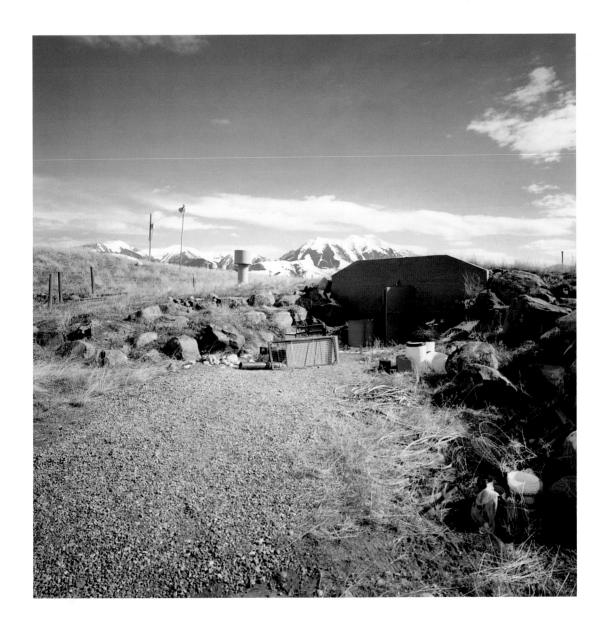

Phillip Hoag's shelter, Emigrant, Montana, 2003

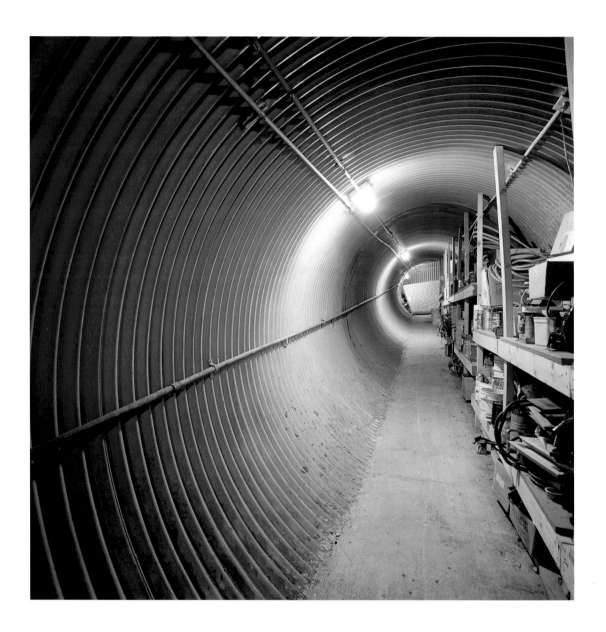

Phillip Hoag's shelter, Emigrant, Montana, 2003

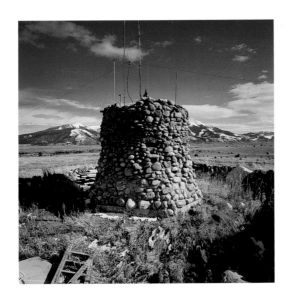
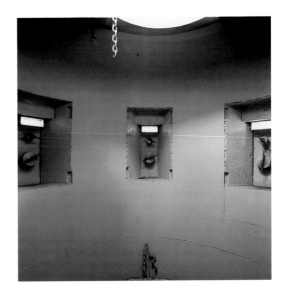
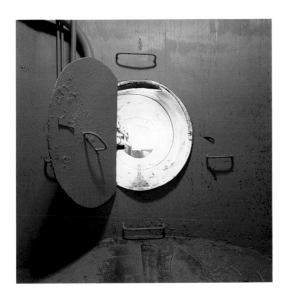
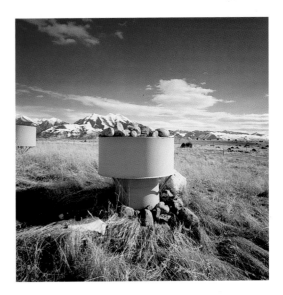

Phillip Hoag's shelter, Emigrant, Montana, 2003

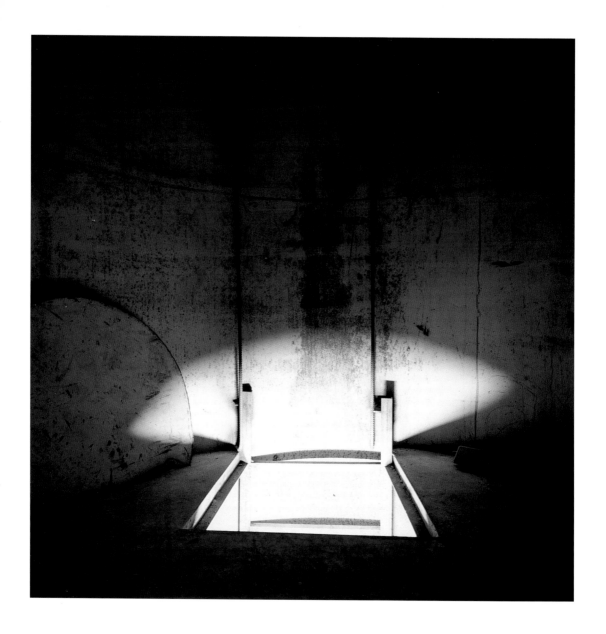

Phillip Hoag's shelter, Emigrant, Montana, 2003

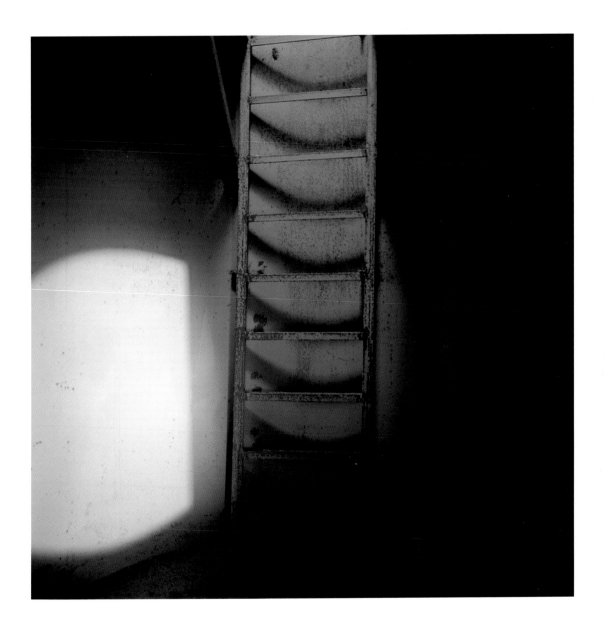

Phillip Hoag's shelter, Emigrant, Montana, 2003

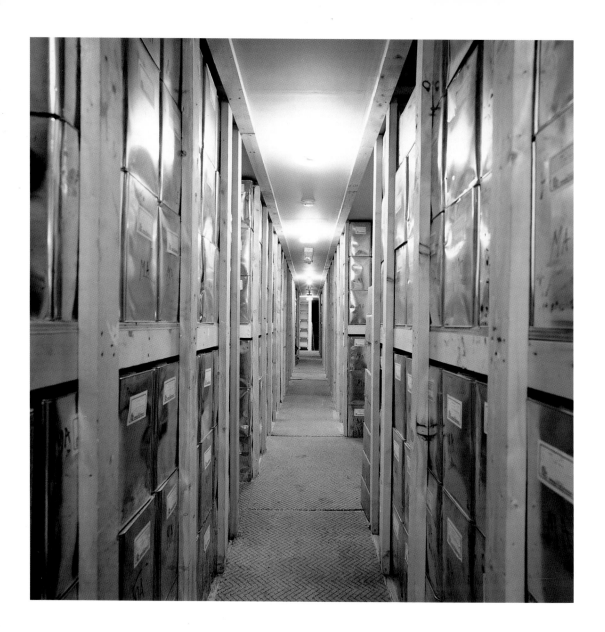

Phillip Hoag's shelter, Emigrant, Montana, 2003

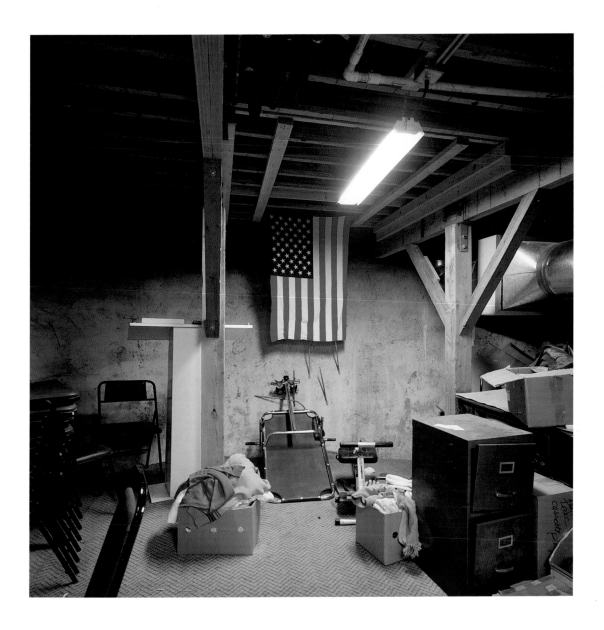

Phillip Hoag's shelter, Emigrant, Montana, 2003

Refrigerator in kitchen area of shelter managed by Charlie Hull, Emigrant, Montana